AMERICAN BALLADS

THE PHOTOGRAPHS OF MARTY STUART

AMERICAN BALLADS

THE PHOTOGRAPHS OF MARTY STUART

Edited by Kathryn E. Delmez

with an introduction by Marty Stuart

and an essay by Susan H. Edwards

FRIST CENTER FOR THE VISUAL ARTS

VANDERBILT UNIVERSITY PRESS

NASHVILLE, TENNESSEE

For the Frist Center for the Visual Arts
Copyeditor: Janna Stotz
Publications Manager: Wallace Joiner

Cover design by Bruce Gore
Text design by Dariel Mayer
Composition by Vanderbilt University Press

Print and color management by iocolor, Seattle
Printed in China on acid-free paper

Library of Congress Cataloging-in-Publication Data on file
LC control number 2014003764
LC classification number TR817.S74 2014
Dewey class number 770.92—dc23

ISBN 978-0-8265-2017-3

Cover illustration: Marty Stuart. *Bill Monroe, Last Winter*, 1995.

All exhibition photographs are archival pigment prints.
In addition to all plate images, Figures 3, 8, and 10 are
provided courtesy of the artist and © 2014 Marty Stuart.

THE FRIST
CENTER FOR THE VISUAL ARTS

Published in conjunction with the exhibition
American Ballads: The Photographs of Marty Stuart
(May 9–November 2, 2014) at the Frist Center
for the Visual Arts, Nashville, Tennessee
(www.fristcenter.org)

The Frist Center for the Visual Arts
is supported in part by:

METRO ARTS

the arts
changing lives!
TENNESSEE ARTS COMMISSION

ART WORKS.
arts.gov

CONTENTS

FOREWORD AND ACKNOWLEDGMENTS

MARTY STUART FANS KNOW HIM as a musician, songwriter, platinum recording artist, five-time Grammy winner, member of the Grand Ole Opry, and country music icon. In museum circles he is widely recognized for his comprehensive collection of country music artifacts and as a historian of the genre. Stuart's photography has been exhibited and published previously, but it remains less known and written about than its merits warrant. *American Ballads: The Photographs of Marty Stuart* accompanies an exhibition of the same name held at the Frist Center for the Visual Arts, which presents selections from his images of musicians, fans, and the Lakota people and their culture. This publication includes additional photographs from the same bodies of work.

In 2004, Frist Center Curator Kathryn Delmez suggested an exhibition of Stuart's photography. Sometimes even the best ideas seem to move at a snail's pace in museum time. In this regard art history is connected to the slow food movement. Knowing where something comes from and its connections to place can enrich our appreciation and reward the wait. Delmez and Stuart spent hours together reviewing photographs and honing their decisions for what would be in the exhibition and what would be added to the book. Throughout the process, curator and artist shared mutual respect and came to consensus.

Our friends at Vanderbilt University Press, director Michael Ames in particular, deserve boundless apprecia-

tion. Over the years, our collaborations have become streamlined by familiarity without ever compromising the freshness of enthusiasm for the next project. We thank Dariel Mayer for her thoughtful and elegant design and for overseeing production. On behalf of everyone involved I thank Joell Smith-Borne, copyeditor, for her attention to detail.

We are indebted to Maria-Elena Orbea, invaluable assistant to Marty Stuart, for her gracious cooperation. Her knowledge of Stuart's photography is profound. Her quick responses to inquiries, good humor, and can-do attitude were a pleasure for all. Les Leverett must be recognized for his generosity of spirit. We thank him for allowing us to reproduce his photographs in this book and for his support for Marty Stuart and this project.

We are grateful to Kathryn Delmez, who is both the curator of the exhibition and the editor of this publication. She is an ardent champion of Stuart's work, committed to bringing his photographic career to greater attention and appreciation. Her gentle determination is an inspiration and we thank her for her pursuit of excellence. Special thanks to Ellen Pryor, director of communications, for her early feedback on the essay and for all she does to see that the world knows what is happening at the Frist. Special thanks to Janna Stotz, editor at the Frist, who works quickly, efficiently, and tactfully. Wallace Joiner served as registrar, gathering information, coordinating framing,

and securing rights for reproductions. Her production management is the gold standard. Her ability to take crushing deadlines in stride makes every project easier. We gratefully acknowledge the entire staff for their myriad contributions. No exhibition at the Frist would be possible without them.

We thank the Board of Trustees at the Frist, especially Billy Frist, Chairman and President. We gratefully acknowledge the ongoing support of the Metropolitan Nashville Arts Commission and the Tennessee Arts Commission, which is funded in part by the National Endowment for the Arts. It is especially fitting that *American Ballads: The Photographs of Marty Stuart* is presented in the Conte Community Arts Gallery at the Frist. This gallery is free to the public during all open hours. We are grateful to donors Andrea Conte and

Phil Bredesen for making it possible and for their innumerable contributions to the quality of life in Music City.

Few people are more amiable than Marty Stuart. It has been a pleasure for all of us to work with him and we are grateful. We thank him for his eloquent introduction to this book. Most of all we thank him for the extraordinary photographs that inspired this project from the beginning. His many accomplishments are enumerated in the pages within. It is with humble gratitude that we submit *American Ballads: The Photographs of Marty Stuart* to his already extensive list of achievements. Bravo, Maestro.

Susan H. Edwards, Ph.D.
Executive Director and CEO
Frist Center for the Visual Arts

INTRODUCTION

Marty Stuart

I ONCE WROTE A SONG ENTITLED "The Pilgrim." The first two lines,

I am a lonesome pilgrim far from home
And what a journey I have known

truly sum up my life. I began traveling as a professional musician at the age of twelve, and I've seldom slowed down since. I possess a deep affection for the road and its mysterious and sometimes cantankerous ways. It is my office as well as my cathedral of dreams.

When I first began traveling I loved the adventure of going from town to town and exploring what each place had to offer. Whenever possible, on the day of the show I walked the streets and back roads, gathering stories and songs from local folks. I studied everything from the different kinds of architecture that surrounded me to the majesty of the sunsets and how they affected the mood of the town I was in. That first season was filled with the joy of a new musical life taking flight. The applause, the spotlight, the sparkle of the fame, the freedom of "here today, go somewhere else tomorrow" charmed me night after night, day after day, until show business found its mark and became a way of life. I enjoyed every minute of the dance. I still love those things, but most of all it's the people that I've enjoyed along the way, namely the characters. The kind of characters who can be defined as American originals.

I was raised inside the world of country music by some profound musical architects: true originals, pioneers who laid the foundation upon which the empire of country music now stands. In 1972, when I was thirteen years old, Lester Flatt gave me a job in his band. As I have said many times, walking into the Grand Ole Opry with Lester Flatt was the equivalent of walking into the Vatican with the Pope. His endorsement gave me instant acceptance into the family of country music. From early 1973 until late 1974 I lived at Lester and Gladys Flatt's home in Hendersonville, Tennessee, until my family could make arrangements to move from Philadelphia, Mississippi, to join me in Nashville. At the time I wasn't old enough to drive. In order to get out of the house and go somewhere I became Lester's shadow. By doing so I often found myself in the company of Bill Monroe, Roy Acuff, Porter Wagoner, Merle Travis, Grandpa Jones, Ernest Tubb, and Stringbean. They always welcomed me, treated me like family, and gave me reasons to believe I was a part of the tribe. Whether at a concert, the Opry, a recording studio, a truck stop, or poker game, any time any one of these people were present I viewed it as history in motion. However, other than the fans, I seldom saw anyone present with a camera to capture the proceedings.

After seeing bassist Milt Hinton's beautiful jazz photographs hanging in a bookstore in Greenwich Village on my first trip to New York City in 1974, I had a revelation.

It became clear to me that I could document the world of country music with the same approach that Mr. Hinton had taken with jazz. The longer I studied his works that afternoon, the more they seemed to shed their formality and dissolve into snapshots from a family reunion or fond remembrances of buddies on a road trip. The watchword of his style was access. I couldn't wait to get started. I left the store, found a payphone, called home to my mother in Mississippi, and asked her if she'd send me a camera to Nashville. The following week she sent me a Kodak Instamatic, and I began taking pictures. Photography has been a part of my life ever since.

THE NEWLY BUILT INTERSTATE Highway System in the United States was at one time represented on our maps by the color red, while the two lane highways and back roads of the nation were represented in blue. The back roads are where you'll find some of the people that I ad-mire, respect, and always keep an eye out for. I lovingly refer to them as "Blue Line Hotshots." They are rene-gades unaffected by popular opinion or mainstream society's social standards. Roger Miller once said, "These people flush to the beat of a different plumber." I regard my Blue Line Hotshot friends as cultural cor-respondents, good-hearted representatives, each with a story to tell that borders on the fantastic. They are colorful characters who enrich this world with their own brand of magic.

Early in my traveling days I came to realize that when showtime is called, two shows begin simultaneously; one on stage and the other in front of the stage. Many of the characters who pay to get in should charge admission to be seen themselves. The poet John D. Loudermilk once asked me, "Do you know who the most eccentric of our constituents are?" I replied, "Who?" His response was, "The audience." I agree. It's the town characters and the county legends who give America its glow. For instance, it takes courage to show up at a rural fair at ten-thirty in the morning, put on a white sequined jumpsuit, trans-form yourself into Elvis Presley, walk out into a tent on the midway, and sing your heart out karaoke style to three people. It's not a job for the faint of heart.

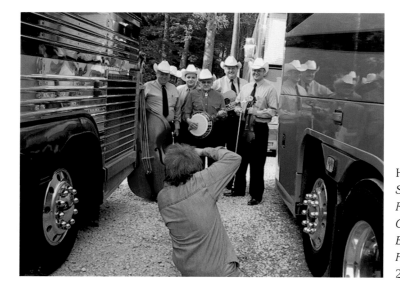

Harry Stinson. *Marty Stuart photographing Ralph Stanley and his Clinch Mountain Boys, Bean Blossom Bluegrass Festival, June 17, 2006,* 2006. © Harry Stinson

IT ALSO TAKES AN INORDINATE amount of courage and strong heart to negotiate the day-to-day existence on the Pine Ridge Indian Reservation in Shannon County, South Dakota. Broken promises, broken treaties, broken hearts, poverty, abandonment, diabetes, alcoholism, drug addiction, social abuse, and despair are all issues that are present every morning when the sun comes up. I wrote a line in my song "Badlands" that speaks of the demons surrounding these plagues.

> It's a wilderness that lies in a broken promise land
> Where the devil and his soldiers hang around
> like next of kin.

That's the report from the dark side of the poorest county in the United States of America.

But the view from the spirit-filled side of Pine Ridge encompasses the many wonderful people whose lives are rooted in tradition and empowered by love, nobility, compassion, and integrity. They are the holy ones, steadfast in their beliefs, who regardless of circumstances believe that good will come again to the Badlands. Meanwhile those people *are* the good; they carry the banner of hope. My first trip to Pine Ridge was in the early 1980s, and I've been going back there ever since. When I shook hands with the Lakota people for the first time, I felt as though I was touching the heart of the United States of America. In the presence of some of the elders, I bowed.

Mr. William "Bill" Horn Cloud was the first person to put his arm around my shoulder and welcome me as family onto the reservation. At the time, Mr. Horn Cloud was the oldest living descendant of a survivor of the Wounded Knee Massacre, which occurred at Pine Ridge on December 29, 1890. His wife, Nancy, was the great-granddaughter of Chief Red Cloud, who to this day is regarded as the tribe's most esteemed leader. Bill and Nancy Horn Cloud were royalty on Pine Ridge. I was told by a young Lakota man one day, "Bill Horn Cloud is our Moses."

I will always be grateful to my friend, archivist/historian/teacher John L. Smith, for taking me beyond the outer edge of Pine Ridge and introducing me to the reservation's inner circle of established families. Since then, each visit, ceremony, relationship, photograph, are but treasures to my heart that I will forever cherish. I love the Lakota people. They are my friends and family. I consider it an honor to be a small part of their story.

THE FIERCE SPIRIT OF INDIVIDUALISM is the common bond that unites the masters of country music, the characters from the blue line roads of America, and the Native Americans who live in the shadow of the Badlands: kindred spirits whose theaters range from the solitude of recording studios to the isolated, dark, weird truck stop parking lot to the sacred ground in Indian land where time can stand still for a thousand years without taking a breath or blinking an eye.

This book represents some of those fiercely independent people I've encountered along the way. Their dedication to their personal dreams and visions at sometimes immeasurable costs has in some instances gone on to become inspired offerings to the world's narrative. Thanks to the people in this book, we have more songs to sing, stories to tell and some highly original perspectives offered in this increasingly homogenized world in which we live.

Marty Stuart

MARTY STUART:
BETWEEN BLACK AND WHITE

Susan H. Edwards

THERE ARE THOSE AMONG US who make history and those who keep it. Marty Stuart does both. He was a child prodigy whose musicianship has only increased along with his renown. Although just twelve years old when his career began, Stuart was well schooled in the history of America's vernacular music. Within a year, he was living and working with many of the most revered talents in country music. His desire to savor his encounters with music legends prompted him to borrow a camera from his mother, a photographer of considerable talent herself. His natural aptitude for photography matured quickly. He became the keeper of the flame, a visual historian of country music and a collector of related artifacts.[1] As Stuart's circle broadened, his portraits of musicians, singers, and songwriters expanded to include performers in other genres. He is also a keen observer of the fans of country music, which would include most of us. Turning his camera around, Stuart makes us the stars of his photographs, performers in our own personal dramas. Through his friend, mentor, and former father-in-law Johnny Cash, Stuart came to know the people of the Lakota tribe, Pine Ridge Reservation, their hardships and their profound dignity. This essay examines Stuart as a visual artist, his black and white photographs of music masters, the unglamorous, and his honorary kin among the Lakota.

Not every family that is musical is also visual. There are classically trained musicians and those who play by ear. In a similar vein, developing a photographic eye requires either formal training or astute instinct, and just as in music, the most proficient practitioners usually draw on both sources. "I can't remember a time in my life when a camera wasn't involved. When I was a kid, my [great-]uncle George Day had a portrait studio in Philadelphia, Mississippi, where both my Mother and Father worked. He used me as a subject to try out new film."[2] Clearly, Stuart's awareness of how photographs document and preserve family history can be traced back to that studio.

The influence of family, his mother, Hilda Stuart, in particular, on the development of Stuart's photographic oeuvre cannot be overestimated. While a student at East Central Junior College in Decatur, Mississippi, Hilda began working in the office of her uncle's studio. "As quick as I got my office work done, I'd go down to the darkroom and watch them print."[3] As a young wife and mother, Hilda wanted to assure that the "meaningful moments of daily life" were recorded.[4] In the beginning, she used black and white film, but many of her most compelling photographs are in color and compare favorably with those of Stephen Shore and William Eggleston. *Marty Stuart on family vacation at The Beach Club, Panama City, Florida*, 1967, (fig. 1) shows the future music star poised on a diving board, about to dive into the deep end. A priceless family photo, but devoid of sentimentality. Another image made on the same vacation *John Stuart and*

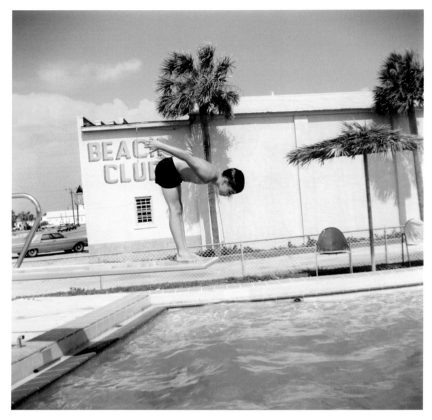

Fig. 1. Hilda Stuart. *Marty Stuart on family vacation at The Beach Club, Panama City, Florida*, 1967. © Hilda Stuart

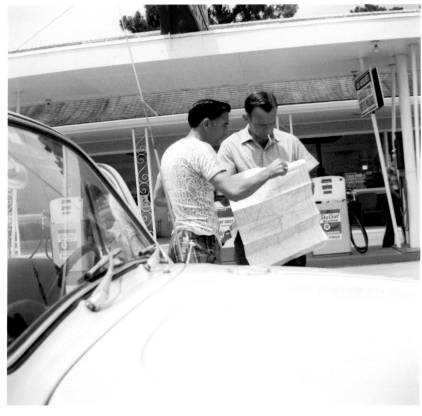

Fig. 2. Hilda Stuart. *John Stuart and Norford Hodgins, en route to Panama City, Florida*, 1967. © Hilda Stuart

Norford Hodgins, en route to Panama City, Florida, 1967, (fig. 2) shows the two men consulting a map outside of the Stuart family's new Volkswagen. The windshield is a study in photographic layering, transparent and yet reflective, recording the sky above and the mirror image of John's shirt juxtaposed with the now dated, robot-like form of a gas pump seen through the glass.

Living with and among photographs made by members of his family, his great uncle's portraits—some even hand tinted—and his mother's keen depictions of mid-century middleclass family life, Stuart developed the ability to capture with dependable consistency images that are memorable and meaningful. His first photograph was of his future wife Connie Smith, who, in 1970 when the snapshot was made, was already a major recording artist. Brazen and smitten at age twelve, Stuart borrowed his mother's camera and approached Smith, who graciously allowed him to photograph her seated behind the steering wheel of her car in a blue-sequined dress that set off her natural coloring, especially her eyes (fig. 3).

Canadian photojournalist Ted Grant is quoted as saying, "When you photograph people in color, you photograph their clothes. But when you photograph people in black and white, you photograph their souls!"[5] Stuart works with equal acumen in color and black and white. Arguably, many of his color photographs of country music artifacts—boots, hand embroidery, fringe and rhinestones, guitars and recording stars—are the soul of country. His black and white photographs are evocative in a different way.

Family life for Stuart is not only family by birth and marriage, but also the Grand Ole Opry family, musicians, fans and fellow travelers, southerners, and Native Americans. Observing and absorbing the visual information around him, Stuart acquires insight. By engaging with his subjects on a personal level, Stuart gains trusted access.[6] Within days of coming to Nashville over Labor Day weekend 1972, Stuart was connected to some of the most revered performers in country music. He was only thirteen years old when he was given a seat on the bus for the weekend with Lester Flatt and the Nashville Grass. He seized the opportunity of proximity to dazzle, flatter, and stun Flatt with his deep knowledge about the Foggy Mountain Boys and Flatt & Scruggs, even offering his opinion on the limitations of the Mapes brand strings Flatt had used previously. By the following weekend, Stuart was officially part of the show.[7] Although barely a teenager, Stuart knew that fortune had smiled on him and that because of Lester Flatt, he had become an insider in the family of country music.[8] In short order, he was up close, personal, an eyewitness to history, and he knew from his mother that a photograph can preserve a memory for a lifetime.

While touring with Flatt, Stuart made his first trip to New York City. There, he wandered into a bookstore in Greenwich Village. On the walls were black and white photographs of jazz greats made by the renowned

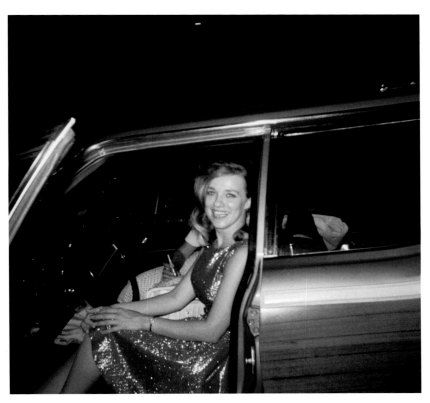

Fig. 3. Marty Stuart. *The Night I Met (and Fell in Love with) Connie Smith, Choctaw Indian Fair, Philadelphia, Mississippi*, 1970.

bass player and photographer Milt Hinton. Hinton has been called the perfect time keeper, a good quality in a bass player but also in a photographer who records slices of time. Photographs of Louis Armstrong, Billie Holliday, Dizzy Gillespie, Miles Davis and others were impressive, but Stuart was moved by something else. Hinton told the behind-the-scenes story about the work that underscores a flawless performance. In one telling photograph we see musicians at practice in a New York City television studio in 1957. Ben Webster, Earle Warren, and Coleman Hawkins, with Count Basie on the piano, Ed Jones on bass, and Freddie Greene on

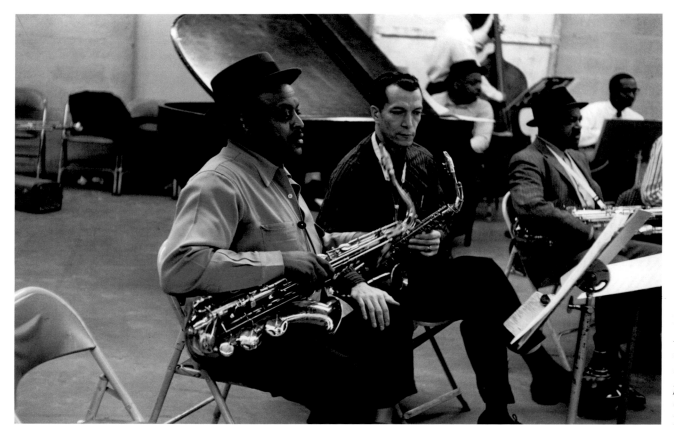

Fig. 4. Milt Hinton. *Ben Webster, Earle Warren, Coleman Hawkins, Count Basie, Ed Jones, Freddie Greene,* Sound of Jazz *television program rehearsal, New York City,* 1957. © Milton J. Hinton Photographic Collection

guitar in the background, are seen rehearsing for *Sound of Jazz* (fig. 4). In another, Bill Evans and Art Farmer take five during a recording session in New York City in 1959 (fig. 5). In short order, Stuart telephoned his mother and asked her to mail him a camera. He knew he could do for country what Hinton had done for jazz, and the timing was perfect. The arc of Stuart's career placed him no more than two degrees of separation from every legend of country music, living and dead. Moreover, Stuart was keenly aware of how quickly country music was changing, and he wanted to be the memory keeper.

Stuart has owned only three cameras in his life: a Kodak Instamatic, a Minolta, and a Nikon.9 He proves over and over that it's a poor cobbler who blames his tools, for Stuart can coax poetry out of the shadows. He considers himself a documentary photographer. His initial aim was to preserve for posterity not only performers on stage, in costume, and under the lights but also private moments backstage, in the recording studio, or in a dressing room; musicians writing, rehearsing, recording, and alone with the muse. In a photograph of Curley Seckler, Roy Acuff, and Lester Flatt made in WSM Radio Studios in Nashville, legendary figures are seen at work

Fig. 5. Milt Hinton. *Bill Evans and Art Farmer, recording studio, New York City*, 1959.
© Milton J. Hinton Photographic Collection

(pg. 25). Stuart understands that the documentary mode shares with country music a democratic alignment with working class values. It is best unadulterated. Thus, he uses only available light, natural light whenever possible.

As Stuart became increasingly interested in photography, he was drawn to the work of Nashville photographers Ed Clark, Jim McGuire, Bill Thorup, and Les Leverett, particularly their images in black and white. The latter was known in bluegrass and country music circles for his commercial work from record album covers to photojournalism for clients that included *Life* magazine and the *Journal of Country Music* among other outlets.

Leverett was the official photographer for the Opry for over thirty years, a position giving him the kind of access and connection that Stuart understood.[10] Leverett was employed by National Life Insurance, the sponsor of the Opry, but he retained artistic control which not only protected his legacy but also gave him considerable freedom and latitude as a documentarian. In the Opry hallway in 1978 he caught Marty Stuart off guard with Bashful Brother Oswald (Pete Kirby), the renowned Dobro player, displaying his oversize pocket watch, a moment that gives us fans a taste of the levity that can occur back stage (fig. 6). In another photograph Leverett records for

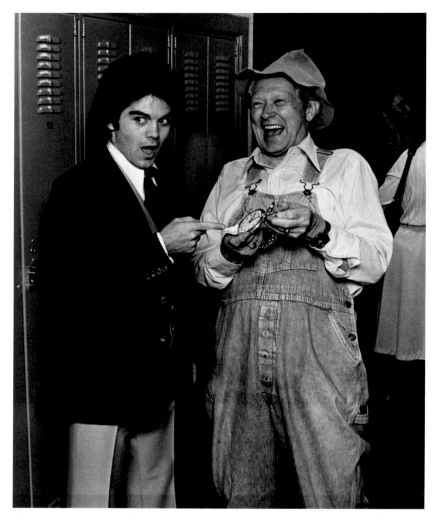

Fig. 6. Les Leverett. *Marty Stuart and Bashful Brother Oswald, November 11, 1978*, 1978. © Les Leverett

the ages Les Paul and Chet Atkins during a 1977 recording session at RCA Studios in Nashville (fig. 7). Seen from below the musical giants are engrossed in their work. Microphones, booms, and electrical cords form an internal architecture of horizontal, vertical, and diagonal lines that also links the artists whose hits topped the charts in several genres.

In the early 1980s, Stuart met a man named for the American patriot Ethan Allen, who lived in a trailer in New Port Richey, Florida (fig. 8). When Stuart asked if he could photograph the gentleman, he was given two conditions: five dollars for the privilege, and the photograph had to be in black and white. At the time, Stuart had color film in his camera. He left and returned with black and white film in the camera, photographed Allen, and even bought the gentleman's hat. The rhetoric of black and white photography conjures historic images, notably those by Farm Security Administration photographers such as Dorothea Lange, one of Stuart's favorites, and the compellingly heartfelt photography of the same era by Stuart's fellow Mississippian Eudora Welty. Stuart sees in Welty's photographs a humanity that can only stem from deep southern roots, intrinsic and inimitable. Her unparalleled storytelling captures with words a tenor of the region that we see frozen in time in her photographs. In addition, black and white television made an indelible impression on the baby boomer generation, and Stuart is no exception. As he has recounted, the early black and white episodes of *Gunsmoke*, *Have Gun Will Travel*, and the *Andy Griffith Show*, for example, leave room for the imagination to wander, to fill in the blanks, to embellish and personalize images in the mind's eye.[11] It is not surprising then that by complying with Ethan Allen's conditions, Stuart was prompted to rethink the rich potential for ambiguity "hidden somewhere between black and white."[12]

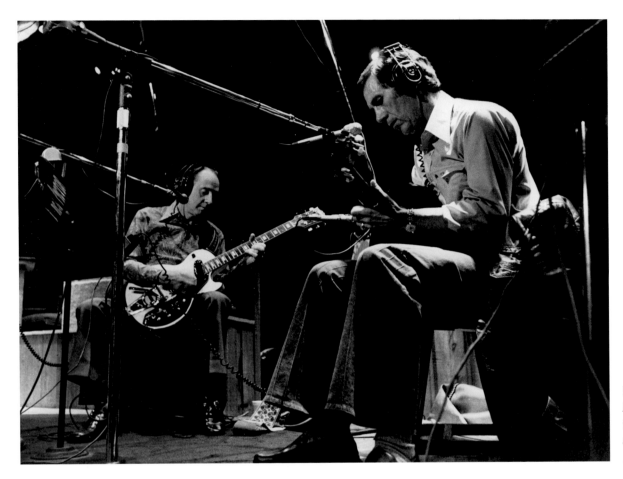

Fig. 7. Les Leverett. *Les Paul and Chet Atkins, recording session at RCA Studios, November 15, 1977*, 1977. © Les Leverett

Marty Stuart mastered the mandolin before he was a teenager, and he remains preeminently associated with it among his multiple talents and many accomplishments. The mandolin (*mandolino*) evolved in Italy during the eighteenth century from string instruments in the lute family. During the 1930s, the mandolin enjoyed a burst of popularity in the American South. Nevertheless, Bill Monroe, the father of bluegrass music, will likely be remembered as the person most responsible for popular-izing the instrument in the later twentieth century. Two of Stuart's photographs of Monroe stand out for their intimacy and perspicacity. In one, Monroe stands among his chickens, white hat covering most of his face, engrossed in his music (pg. 22). We, the audience, are voyeurs watching the master in a private moment with his fellow barnyard performers. The down-to-earth origins of the bluegrass sound alluded to here are incongruously yet intriguingly juxtaposed with the elegant horizontality and

Fig. 8. Marty Stuart. *Ethan Allen*, 1980s.

status of a white Cadillac limousine parked at the back of this humble stage set. Even more haunting is a photograph of Monroe seated alone in his barn (pg. 23). The back lighting is reminiscent of the view of a stage hand or member of the band. We are given the same view Stuart has enjoyed so often when performing with men and women who made history under the bright lights. Beyond the light source, the trees are barren. Winter is approaching. Monroe plays on.

Porter, Dolly, Loretta, Willie, Waylon, Merle, and Emmylou: the stars of country, Americana, roots, and rockabilly are so renowned that we recognize them by only one name. Those names conjure specific songs and recollections. Music shares with photography a connection to the past and our presence in past moments. It sears a wrinkle in the brain that is forever connected to a time, relationship, joy, or heartbreak. We can all relate to Dick Clark's claim that music is the soundtrack of our lives. To keep our visual memories alive, we make and save photographs of people, places, and events that are important to us. Undocumented memories diminish over time, but a photograph can arrest that slow fade to black.

The Carter family's contributions to music are almost incalculable. *A.P. Carter's Cabin, Maces Springs, Virginia* (pg. 18) is little more than a photograph of a lean-to, but for thousands of fans it symbolizes how folk and country music never denigrate humble beginnings. Stuart brings past and present generations of the Carter family members together in *Janette and Joe "Bull" Carter, Maces Springs, Virginia* (pg. 19). Janette and Joe are seen in their living room, instruments in hand, among a clutter of knick knacks and portrait photographs of ancestors on the wall and mantelpiece behind them, a convention that dates back to the earliest uses of photography in the nineteenth century, when the magic of preserving

the past was new. The condensed depth of field draws attention to the photographs within the photograph as memento mori, reminders of the inevitability of time and generations passing.

When June Carter married Johnny Cash, the Carter family history entered a new chapter. No celebrity union could have more tellingly affirmed that the circle will be unbroken. Stuart's association with the Cash-Carter dynasty was one of mutual respect and professional courtesy. Cash was a regular subject for Stuart, in part because of access. Stuart's first wife, Cindy, was Cash's daughter, and Stuart played in Cash's band. Years later, Connie Smith and Marty Stuart lived next door to John and June Cash. By the 1980s, Johnny Cash was an American icon. His music and sound had broad appeal, and he was integral in the shift from old time country to an outlaw subgenre.

Reformed and redeemed, the Man in Black was a study in contrasts. The average person could identify with his complex personal journey. Listening to Johnny Cash sing, one believes grace is possible in a judgmental world. Stuart's famed last photograph of Cash (pg. 17), which conveys both dignity and frailty, is homage on par with portraits by Julia Margaret Cameron of Sir John Herschel and Lord Alfred Tennyson. By the time the photograph was made, Cash was widowed. Still completely in command, his distant stare and solemn expression convey reflection, steely and accepting rather than nostalgic. Stuart caught Cash and Merle Haggard at their last meeting (pg. 53). The once strapping and devilishly handsome musicians sit shoulder-to-shoulder: fragments of their guitars are synecdochic reminders of life-long careers in music. When Johnny Cash played at the San Quentin prison in 1958, Haggard, a twenty-year-old inmate who attended the concert, was inspired to pursue a career in country music. Forty-five years later, the old friends appear to be in conversation, bringing to mind song lyrics Haggard wrote about a convict's last words, "Let my guitar picking friend do my request. Sing me back home."

ITALIAN FILM DIRECTOR FEDERICO FELLINI was famous for his idiosyncratic vision. His films address memory, dreams, fantasies, and desire. Stuart sees many parallels between Fellini characters and southern eccentrics. Like Fellini, Stuart is honest but never condescending. In a body of work he has labeled "Blue Line Hotshots," Stuart chronicles ordinary people doing ordinary things. Although printed road maps are used less and less today, in 1967, when John Stuart took his family on vacation to Panama City, Florida, it was common to consult your Rand McNally for directions. Skeins of blue, red, and grey crisscross the country, marking the highways and roads that connect people from every walk of life. *Hotshot* is a term that dates back to the seventeenth century, when it meant a person who takes reckless aim. In contemporary parlance it refers to a person who is talented or successful in a conspicuous way. Celebrity impersonators are local hotshots, big in their own back yards. As a documentarian of people who reside along the blue lines, Stuart is a latter-day Pieter Breugel, the Elder, whose sixteenth-century paintings of rural life and manners are endlessly appealing. In a similar vein, Stuart records unselfconscious adult twins in matching leopard print capri pants and hairstyles (pg. 81). They look with confidence into Stuart's camera. Their lack of pretense is similar to that of the revelers and workers in a Breugel painting. We are seduced by their devil-may-care wholesomeness. For us as viewers, they are a double, a repetition of the same image, which is intrinsic to the photographic practice of printing multiples from a single negative and an internal reference to the medium itself.

To date, Stuart uses only film and traditional photo-chemical printing. He is an admirer of his predecessors such as those documentarians mentioned earlier, Lange and Welty, but also of the work of Diane Arbus, who is known for her square format black and white photographs of marginal people. Arbus was more compassionate than is sometimes acknowledged, and Stuart relates to her observations of the overlooked in our society. Stuart is a champion of his subjects. When he is photographing celebrities, he does so from the perspective of a fan as well as a peer. He understands how persona serves one professionally, yet he appreciates that every person has private moments, dressed down so to speak, when we are naked before the truth of who we are. Stuart identifies with and captures the vulnerability of big shots from truck drivers (pg. 77) to evangelists (pgs. 69–71). Stuart's technical decisions reinforce the integrity of directness achieved using predominately natural light.

Stuart is an insider among the regional characters he encounters at rodeos, state fairs, and truck stops. Conversely, fashion photographer Richard Avedon was commissioned by the Amon Carter Museum to create a photographic study of everyday working class people, produced in *In the American West*. It was criticized somewhat unjustifiably as potentially condescending given Avedon's perspective as a New York Jewish sophisticate. Avedon was a master technician, always concerned with paper quality, printing, and light. His portraits are generally frontal views on a neutral background. Photographing comparable subjects, Stuart, although more relaxed about technical issues, employs a strategy similar to Avedon's by having his subject look straight into the camera. For example, in *Country Music Fan* a young woman stands in sharp focus before a group of onlookers, perhaps fans straining for a closer look at the celebrity photographer (pg. 79). The slightly blurred mass of

fans dissolves into background noise. The subject stands like an ancient goddess in a classic contrapposto position, ringlets draped over one shoulder, smiling enigmatically. Blue jeans, necklace, earring, and a sleeveless t-shirt imprinted with "Murphy's Country Palace" bring us back to modern times and the realm of local big shots.

Stuart says he has always seen beauty shops as cultural hubs in the community, and one of his favorite short stories by Eudora Welty is "The Petrified Man."[13] The protagonists are Leota, a beautician, and Mrs. Fletcher, her customer. A small town beauty shop is the setting for an exchange of gossip and self-exposure, a place where eventually the main characters reveal their envy, vanity, and betrayal. Those who enter wanting to be more beautiful and those assisting in the process confess their superficiality and lack of inner beauty. In his photograph of a lone figure standing adjacent to a stenciled sign for a beauty salon (pg. 83), there is a handwritten seven digit telephone number. The name of the beauty salon is "Enchanted Images," which here serves as a double entendre for the enchantment made possible at the beauty salon as well as the enchanting power of photographic images. Stuart appears in a double self-portrait reflected on the surface of the sunglasses. Since the nineteenth century photography has been the principle means by which image and consequently fame were established and preserved. On first glance the photograph is the simple juxtaposition of figure and text, but the complexity of literal and semiotic messages and the internal tension this creates are worthy of a second look.

ON A VISIT TO NEW ORLEANS IN 1999, Stuart went to A Gallery for Photography. There, he saw a photograph by Edward S. Curtis titled *Vanishing Race—Navaho,* circa 1904 (fig. 9), in which a group of Navajos on horseback

Fig. 9. Edward S. Curtis. *The Vanishing Race–Navaho*, circa 1904. Courtesy Library of Congress Prints and Photographs Division, Washington, D.C. 20540, LC-DIG-ppmsca-05926

file into a canyon with one lone figure turned to look back. Stuart was familiar with Curtis's renowned study of Native Americans, *The North American Indian*. He had bought two photogravures from the series when he was a teenager. During the early 1980s, the Johnny Cash band, including Stuart, played a benefit at the Holy Rosary School on the Pine Ridge Reservation in South Dakota. Stuart immediately felt a strong kinship with the Lakota people. Twenty years later, after numerous visits, he would be inducted into the tribe as a family member.[14]

Seeing *Vanishing Race* in person was a transformative experience for Stuart. Curtis's message was clear.[15] He was convinced he was recording the end of an era, symbolized by the backward glance of one of the Navajo. This resonated with Stuart personally, who saw himself as an eyewitness and a participant in the generational shift from traditional country to a more hybrid aesthetic in music and costuming. For Stuart the radiant plumage and beading of Lakota ceremonial dress correlates with rhinestone and embroidery performance ensembles by designers and tailors Nudie Cohn and Manuel Cuevas (fig. 10).[16] This is poignantly articulated in the sartorial choices of two members of the Lakota tribe. One sports a Nudie jacket embroidered with a design on the front and a Native American in full headdress on the back (pgs. 100–101). Conversely, another man wears a t-shirt screen printed with a picture of Johnny Cash offering a bad boy gesture (pg. 104).

Since Stuart began visiting the Pine Ridge Reservation, it has had a poverty rate of between eighty and ninety percent and a comparable figure for unemployment and alcoholism.[17] For Stuart it was all the more impressive that the observation and practices of traditional ceremonies and rituals elevate the dignity and spirits of the Lakota people. As a documentarian, Stuart records what is before the camera lens with a social conscious-

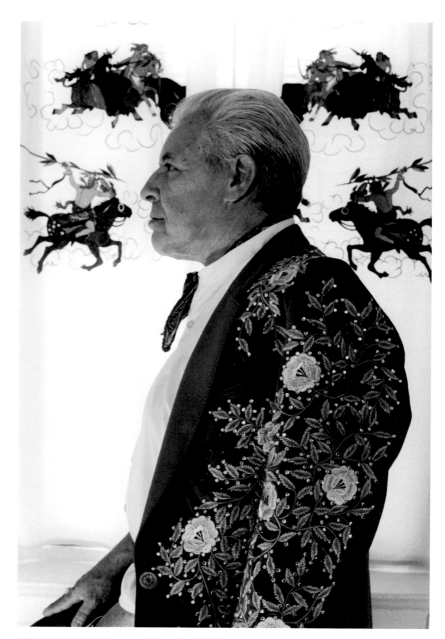

Fig. 10. Marty Stuart. *Manuel*, 1999.

ness consistent with the compassionate reportage of Jacob Riis, Lewis Hine, Dorothea Lange, and Mary Ellen Mark. A man is passed out on the porch of a building with cracked walls, perforated metal window coverings, and what appears to be a single four-by-four support beam (pg. 99). The exterior disrepair is contrasted by the equilibrium of the photograph's interior architecture of rectangles and horizontal and vertical elements. The lone figure is a mark of human presence. A cross is painted on the door along with the words "one love, native pride."

The Lakota ceremonial dress is colorful and detailed with fringe, knotting, feathers, and beads. Ceremonies and dances are passed down from generation to generation and often involve helping the soul along a spiritual path. Stuart's portraits of the Lakota, adults and children, in native dress bring to mind the sort of studio portraits made by his great uncle, George Day, of local patrons wearing their Sunday best (pgs. 108–9). Many Native Americans called Edward S. Curtis a shadow catcher. In the nineteenth century, terms like this one and others such as a "mirror with a memory," used to describe daguerreotypes, told us literally what photography does and how it does it. Stuart ably transports the original magic of photography into the late twentieth and early twenty-first centuries. His photograph of two Lakota women (pg. 103) depicts the dignity and wisdom of lined faces: their once jet-black hair faded to white. Layers of clothing drape their small-framed figures. Stuart avoids maudlin sentimentality, catching instead a balance of nobility and levity as two elders stand for the ages under a quirky shade umbrella.

Stuart photographed a tattered American flag in a small Lakota cemetery (pg. 91). The flag is a veritable weather vane, for the wind is strong enough to unfurl the flag to full horizontality. The American flag, the emblem of patriotism, would reasonably resonate differently for the Lakota. The United States is an adopted country for them, and Christianity, symbolized by crosses as grave markers, is an adopted religion. No people are present, drawing attention to the flat, treeless landscape of the South Dakota plains upon which so much Native American blood was spilled. Edward S. Curtis predicted the winds of change. Stuart testifies to the Lakotas' durability, perseverance, and retention of cultural identity against the odds.

Marty Stuart's early exposure to photography led inevitably to his pursuit and mastery of the medium. A Marty Stuart photograph can come "slowly stealing" to conjure a memory from the past or to play a familiar refrain. He is always looking, recording, collecting, preserving, and galvanizing our histories as Americans, southerners, country music fans, and students of humanity and humility. Stuart emits and attracts beauty in multiple forms. It would be short sighted to see his charisma as star power, although he has that in abundance. It is more. Stuart was born gifted but he has also refined his talents at every turn. One can easily say that music and art are not what Marty Stuart does, but who he is. His foray into black and white photography yielded a body of work rich by virtue of his abilities and compelling because of the ambiguity hidden within. An enduring legacy of fabulous superlatives.

NOTES

1. *The Art of Country Music: The Marty Stuart Collection*. The Ogden Museum of Southern Art, New Orleans, August 2010, and *Sparkle & Twang: Marty Stuart's American Musical Odyssey* organized by the Tennessee State Museum, Nashville, TN (June 6–November 11, 2007, followed by a national tour).

2. Statement by the artist, published in conjunction with the exhibition *Pilgrims: The Photographs of Marty Stuart* at Cheekwood Botanical Gardens and Museum of Art, Nashville, Tennessee, June 11, 1999. *www.martystuart.com/Cheekwood-6-11-99.htm*.

3. Hilda Stuart*, Choctaw Gardens* (Taylor, MS: The Nautilus Publishing Co., 2012), x.

4. Ibid., xi.

5. Thelma Fayle, *Ted Grant: Sixty Years of Legendary Photojournalism* (Victoria, BC: Heritage House Publishing Co., 2013), 208.

6. Conversation with the author, September 28, 2013.

7. Marty Stuart, *Country Music: The Masters* (Naperville, IL: Source-books MediaFusion, 2008), 4–5.

8. Ibid, 5.

9. Conversation with the author, September 18, 2013. See also *Country Music: The Masters,* 4.

10. Les Leverett, *Blue Moon of Kentucky: A Journey into the World of Bluegrass and Country Music as Seen through the Camera Lens of Photo-Journalist Les Leverett* (Madison, NC: Empire Publishing, Inc., 1996), 6.

11. Conversation with the author, September 27, 2013.

12. Marty Stuart, *Pilgrims: Sinners, Saints, and Prophets: A Book of Words and Photographs* (Nashville, TN: Rutledge Hill Press, 1999), n.p.

13. Conversation with the author, September 27, 2013; Eudora Welty, "Petrified Man," in *The Collected Short Stories of Eudora Welty* (San Diego, New York, London: Harcourt Brace & Co., 1980), 17–28.

14. On June 22, 2005, Marty Stuart was adopted into the Lakota tribe. Marvin Helper proclaimed, "The spirits bring in the name. He will carry that for the rest of his life. The Lakota name that has been given to Marty Stuart is O YATE' Ö CHEE YA'KA HOPSILA (the man who helps the people). He is adopted into the Lakota tribe: he is now family." A ceremonial dance followed. This event was recorded by Stuart for a Country Music Television (CMT) special on Badlands in Pine Ridge; conversations with the author, September 27 and October 8, 2013; correspondence with the author, October 10, 2013.

15. Recent scholars see Curtis as too pessimistic given the vitality of Native American literature and arts but "correct in his judgment that he was living at a time that was the last possible one for many memories to be recorded (such as those of Hunts to Die, who passed on much Apsaroke or Crow lore for inclusion in *The North American Indian*) and for many images to be captured by his magic box (such as the faces of figures like Little Wolf and Red Cloud or the celebration of fading ceremonies like that of placating the spirit of a slain eagle)." Mick Gidley, "Edward S. Curtis (1868–1952) and *The North American Indian*," *memory.loc. gov/ammem/award98/ienhtml/essay1.html*. See also David R. M. Beck, "The Myth of the Vanishing Race," *memory.loc.gov/ammem/ award98/ienhtml/essay2.html*. Both essays are part of *Edward S. Curtis in Context, (memory.loc.gov/ammem/award98/ienhtml/ special.html)*, a special presentation to accompany the digital archive *Edward S. Curtis's* The North American Indian, Northwestern University Digital Library Collections.

16. Mick Gidley, "Edward S. Curtis."

17. "Pine Ridge Indian Reservation," *www.re-member.org/pine_ ridge_reservation.aspx*.

THE MASTERS

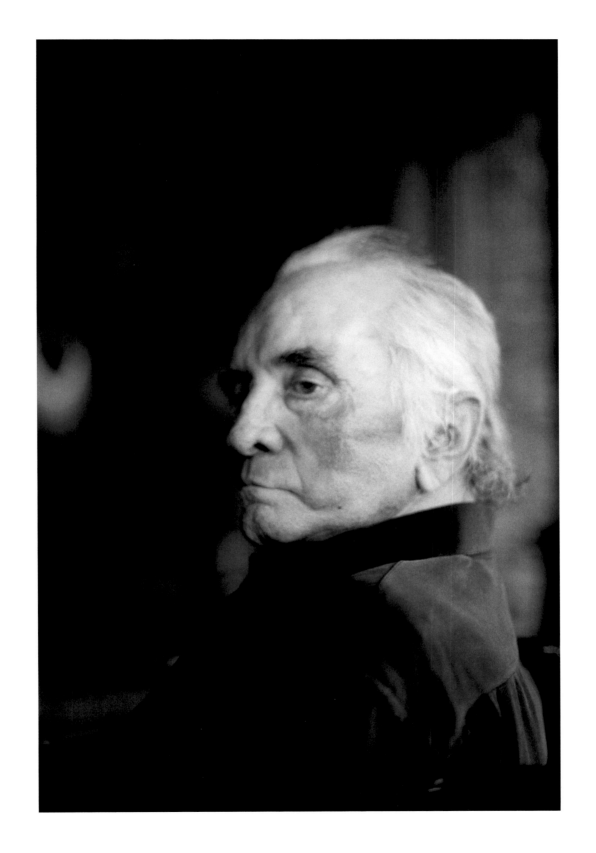

John R. Cash, Last Portrait, September 8, 2003, 2003
Hendersonville, Tennessee

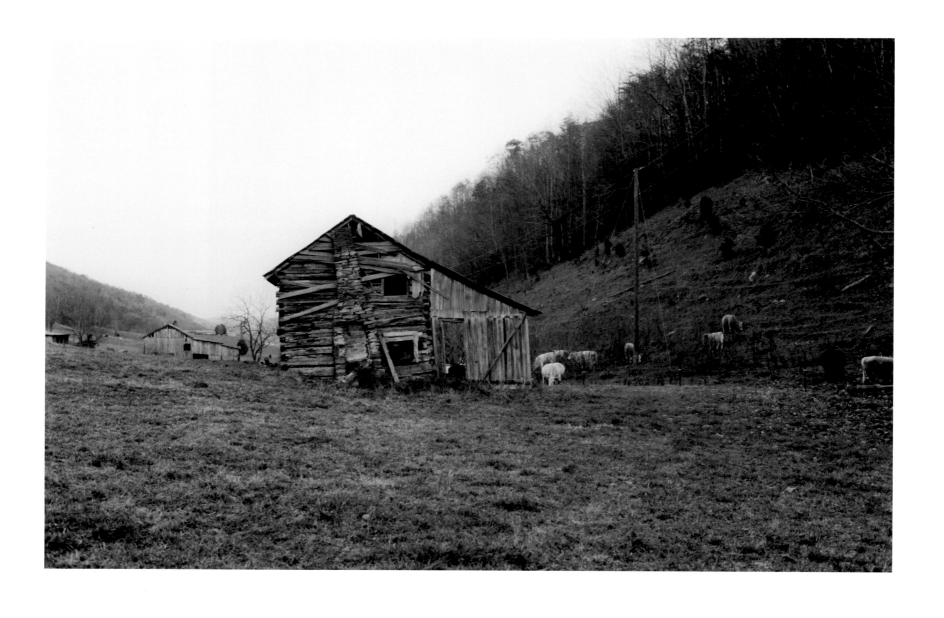

A.P. Carter's Cabin, 1997
Maces Springs, Virginia

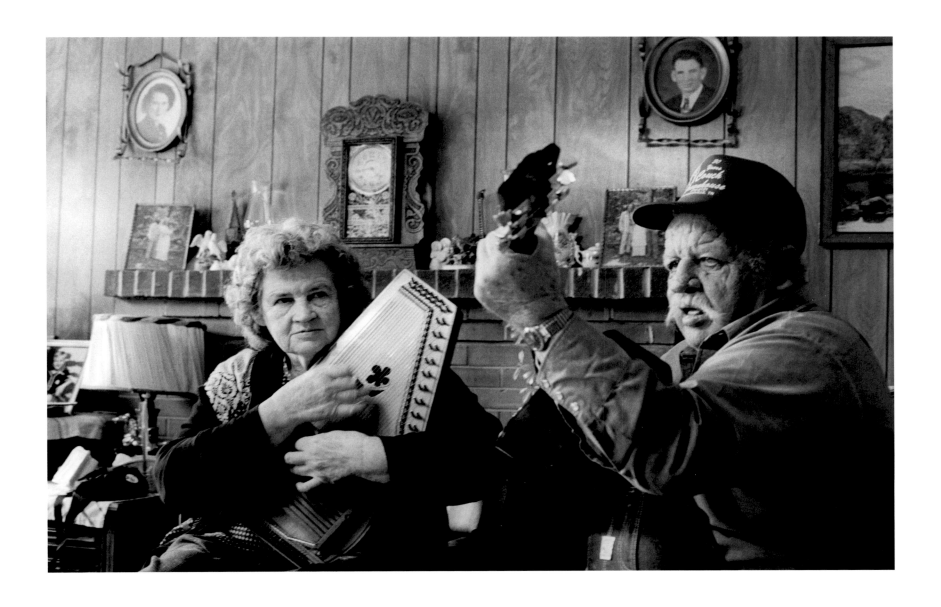

Janette and Joe "Bull" Carter, 1997
Maces Springs, Virginia

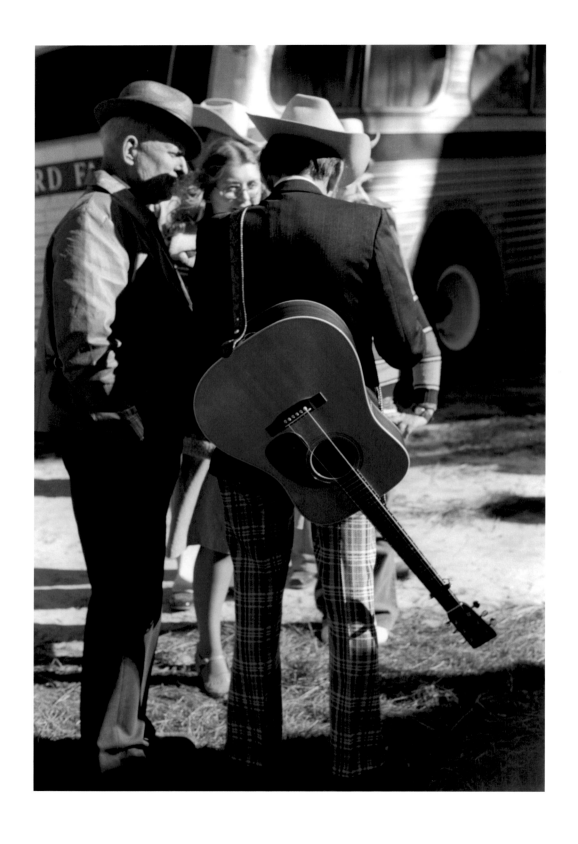

Lester Flatt, 1975
Douglas, Georgia

The Texas Troubadour, Ernest Tubb, 1974
San Antonio, Texas

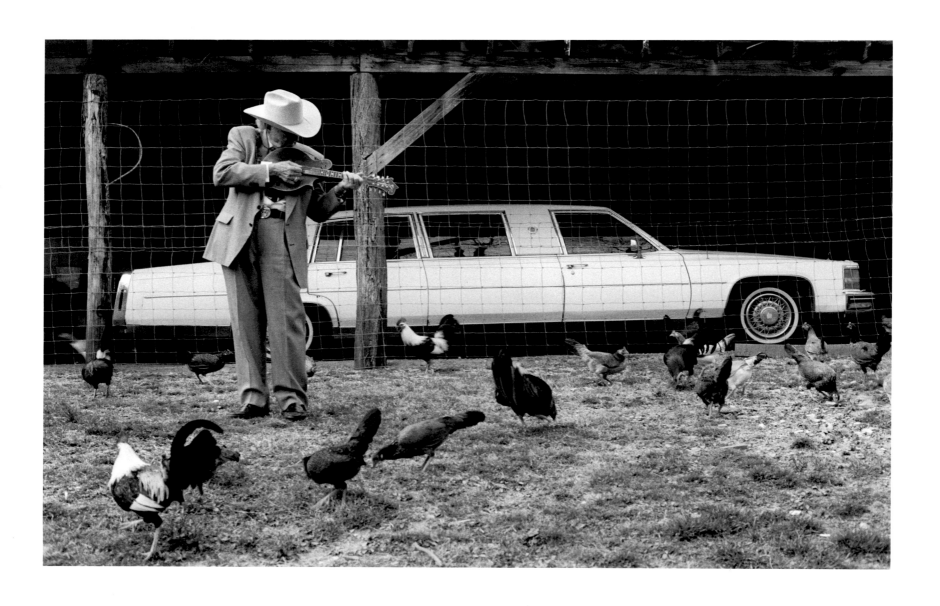

The Chicken Reel, the Father of Bluegrass, Bill Monroe, 1995
Goodlettsville, Tennessee

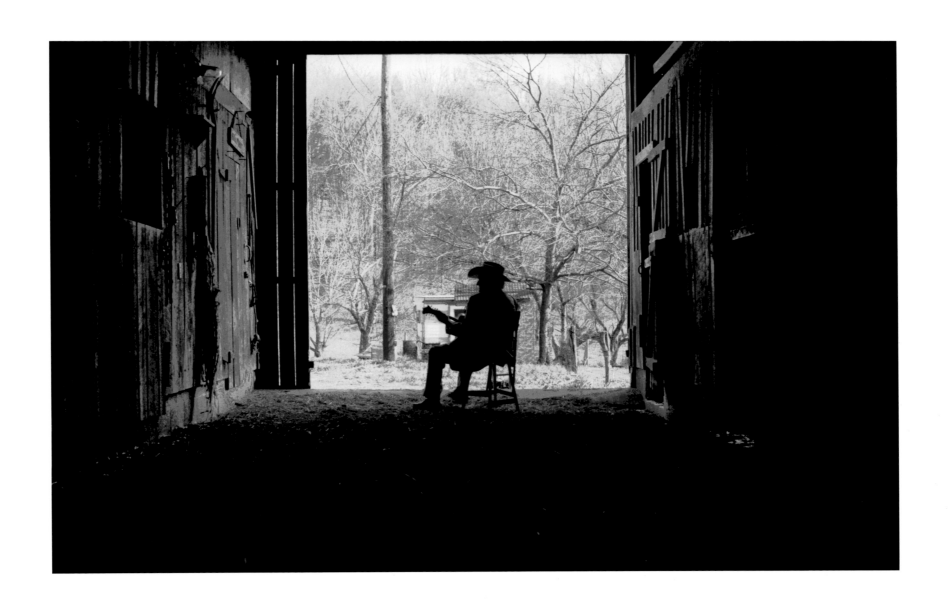

Bill Monroe, Last Winter, 1995
Goodlettsville, Tennessee

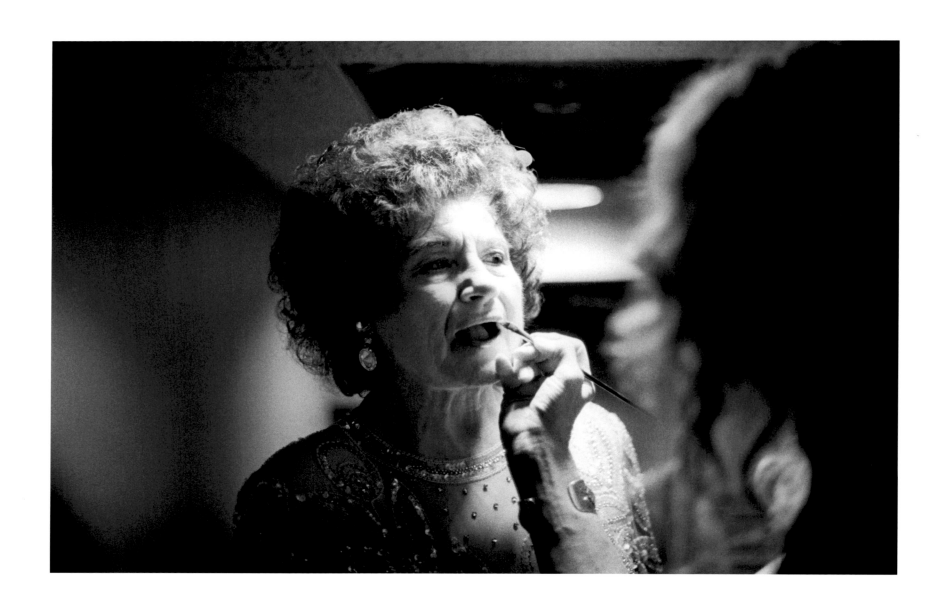

The Queen of Country Music, Kitty Wells, 1994
Ryman Auditorium
Nashville, Tennessee

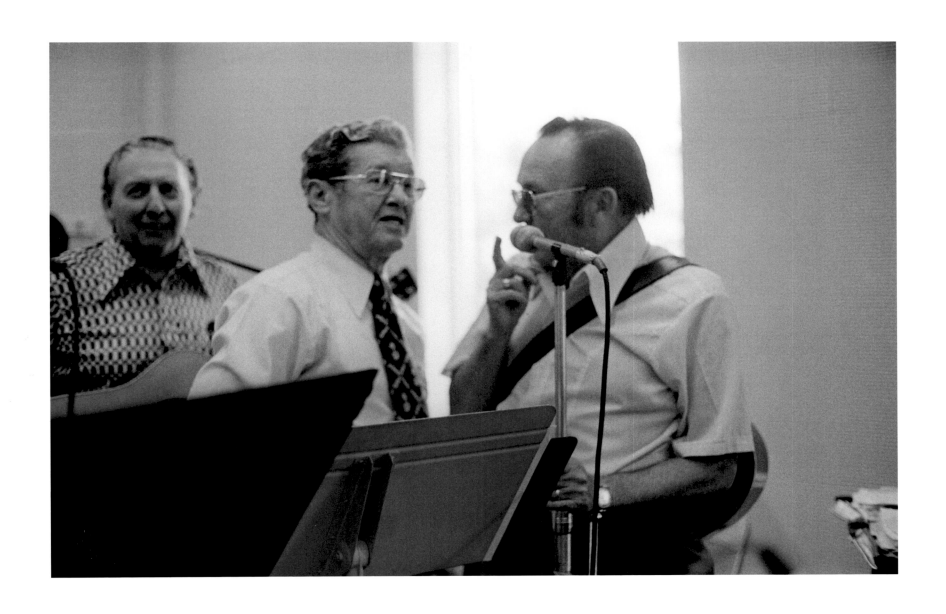

Curley Seckler, Roy Acuff, and Lester Flatt, 1974
WSM Radio Studios
Nashville, Tennessee

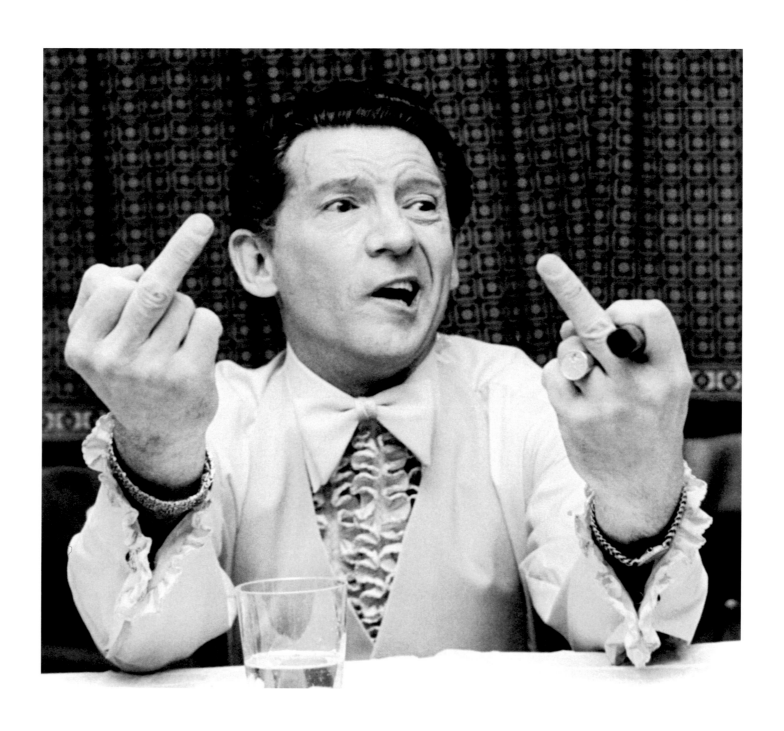

The Killer, Jerry Lee Lewis, 1982
Paris, France

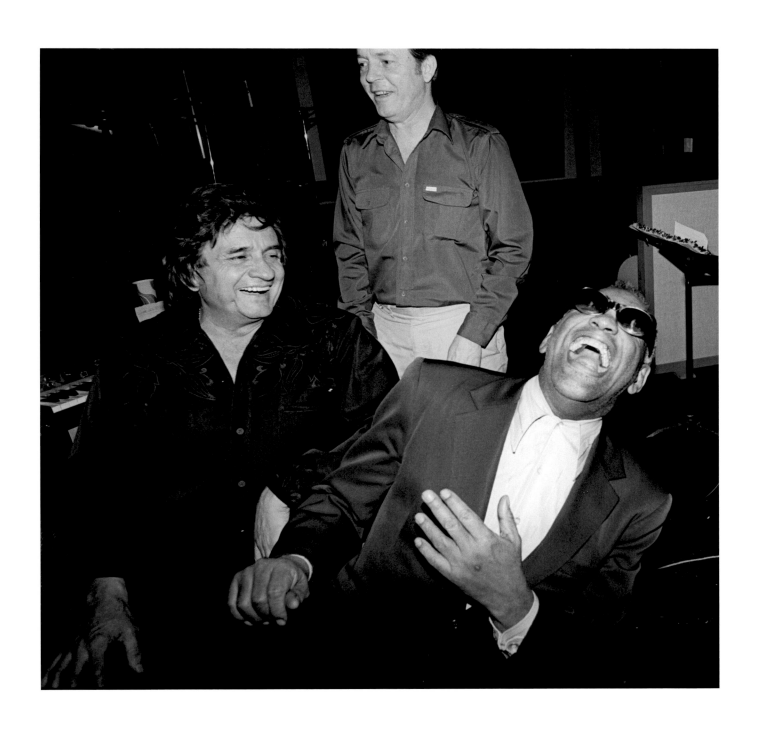

Late Night Studio A, Johnny Cash,
Billy Sherrill, Ray Charles, circa 1980
Nashville, Tennessee

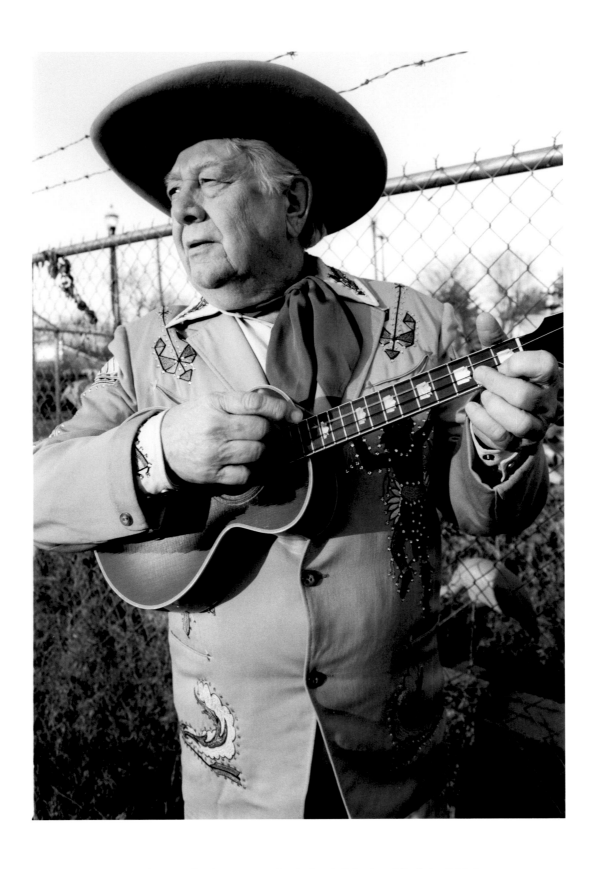

Cowboy Jack Clement and His Soul-Stirring Ukulele, 2004
Nashville, Tennessee

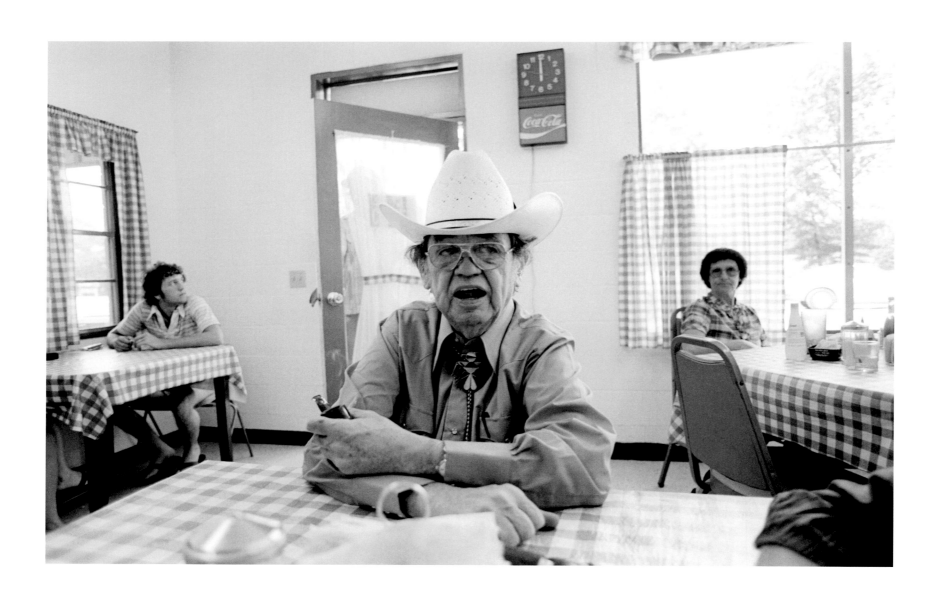

Merle Travis, Twelve O'Clock High, 1981
Mountain View, Arkansas

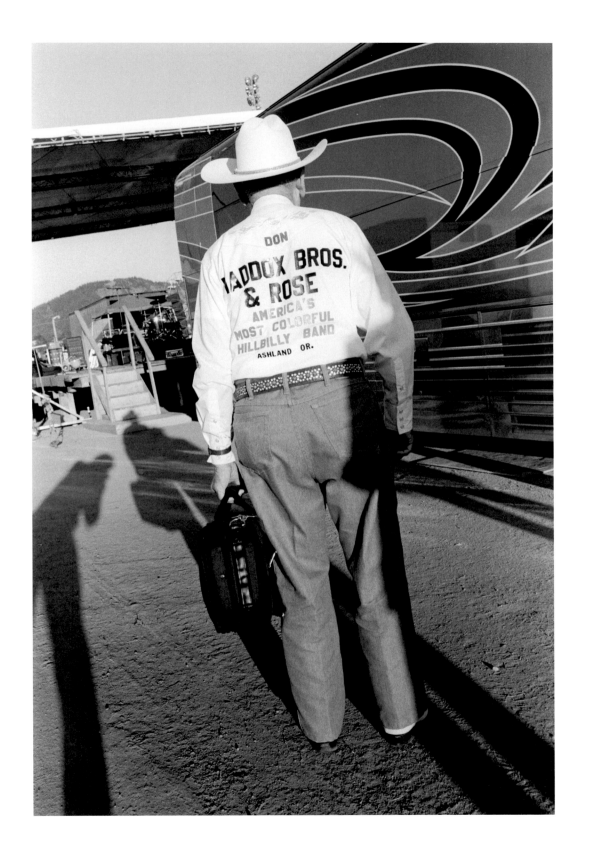

K.C. Don "Juan" Maddox, 2011
Grants Pass, Oregon

Minnie Pearl's Shoes, 2000

Minnie Pearl's Hat, 2000

The King of Broken Hearts, George Jones, 1997
Ryman Auditorium
Nashville, Tennessee

Merle Haggard, Poet of the Common Man, 1994
Hollywood, California

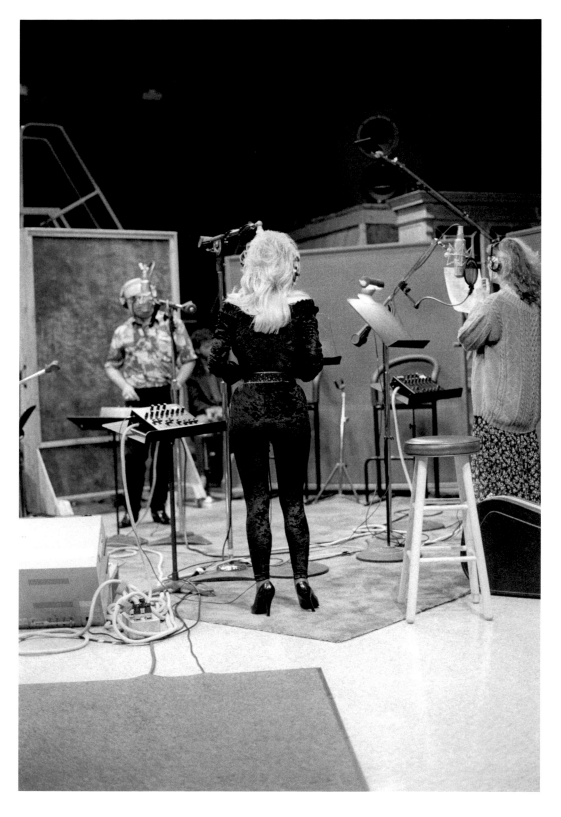

George Jones, Dolly Parton, and Emmylou Harris, 1994
Bradley's Barn Recording Studio
Mount Juliet, Tennessee

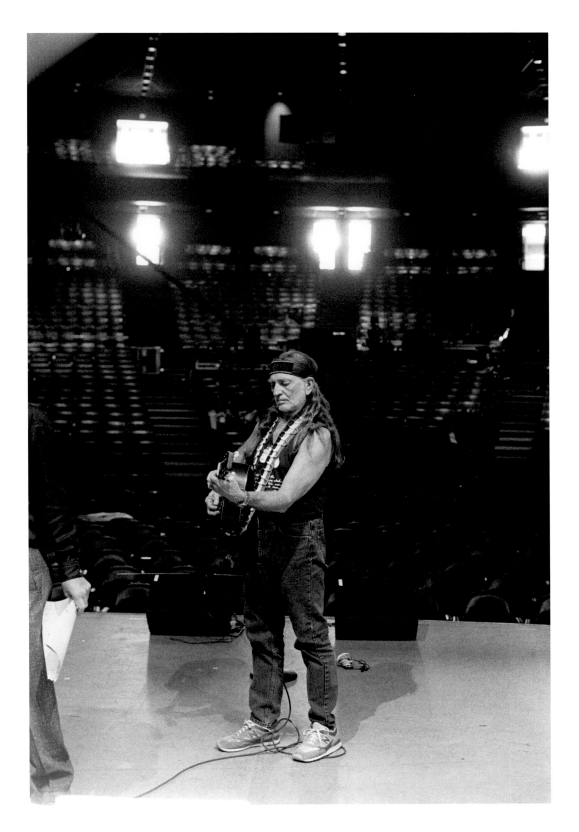

Willie Nelson, 1994
Universal Amphitheatre
Los Angeles, California

"Baby, your grandpa was a man named Hank Williams,"
Hank Williams, Jr., and His Daughter, Katie, 1995
Montgomery, Alabama

Little Jimmy Dickens, 2005
Dressing Room 5, Ryman Auditorium
Nashville, Tennessee

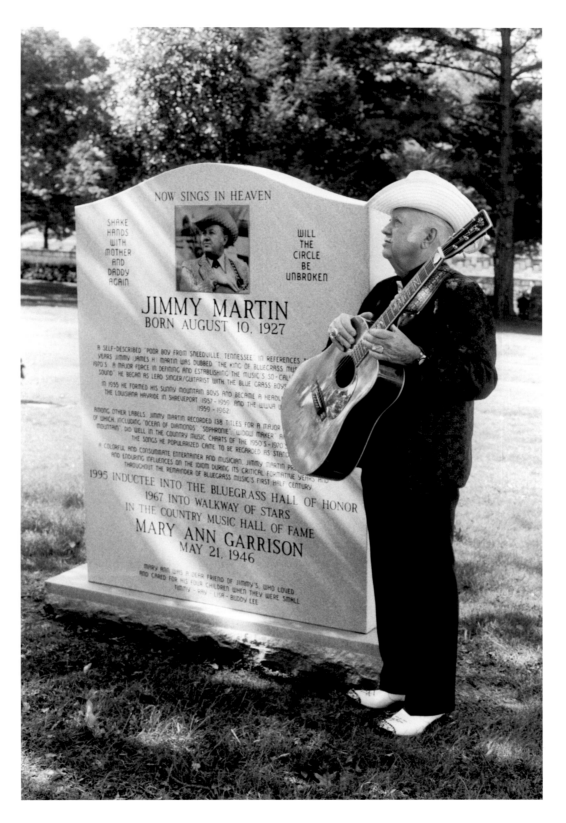

The King of Bluegrass, Jimmy Martin, at his Tombstone, 2000
Spring Hill Cemetery
Madison, Tennessee

J.R. Cash, Snorkle the Pig, and Theodore the Turkey, 1982
Hendersonville, Tennessee

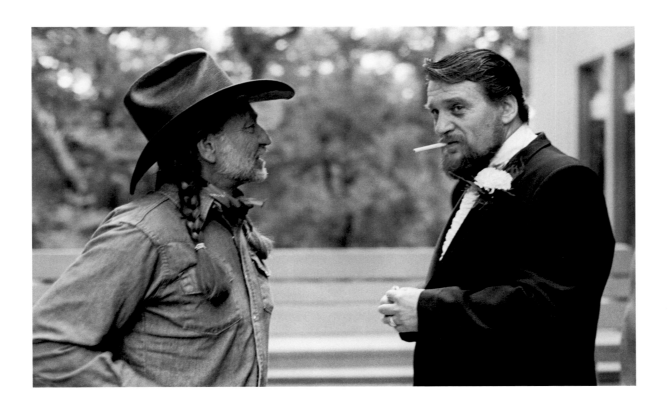

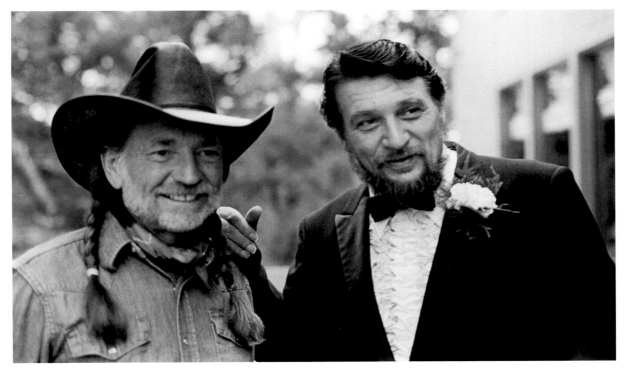

Willie and Waylon, 1985
Brentwood, Tennessee

45

Queenie, Emmylou Harris, 1995
Milan, Italy

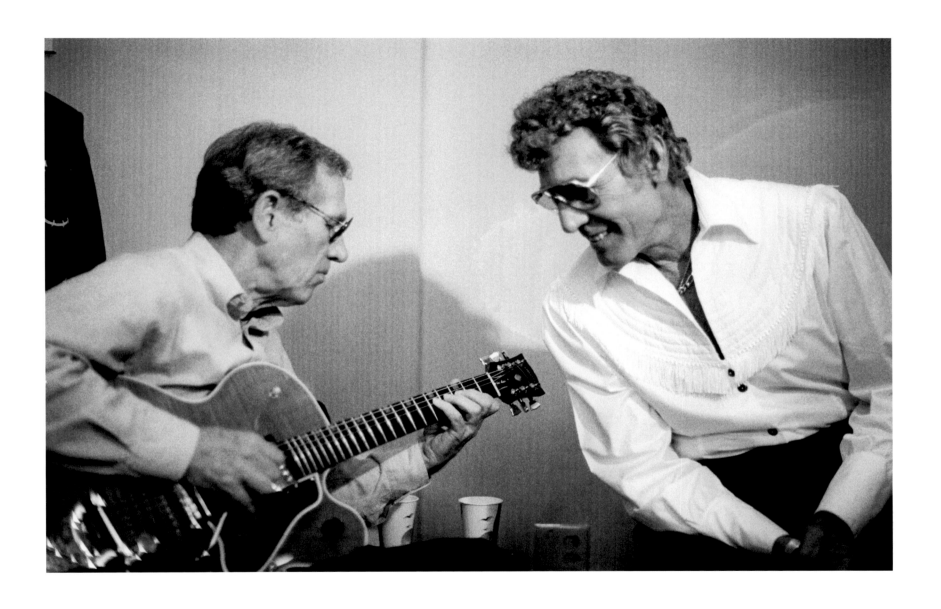

Chet Atkins and Carl Perkins, 1994
Ryman Auditorium
Nashville, Tennessee

Connie Smith, 1997
RCA Studio B
Nashville, Tennessee

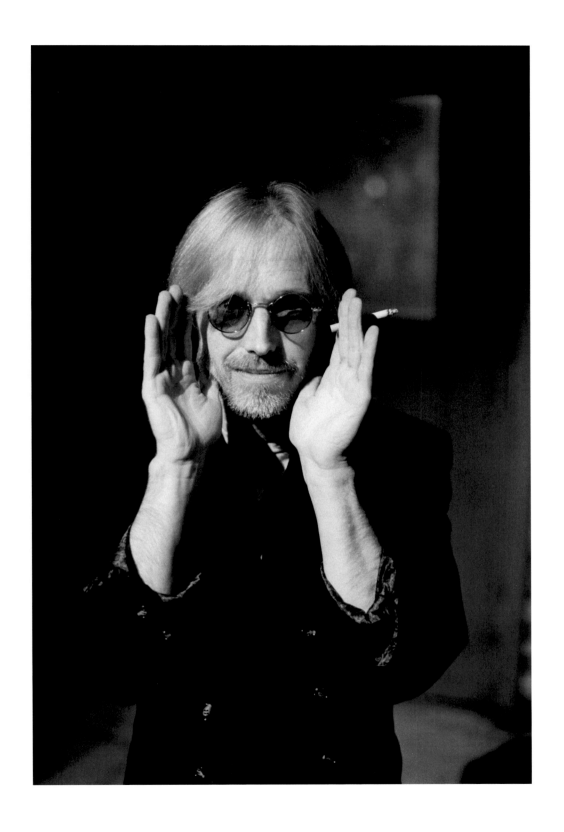

Tom Petty, "You Don't Know How It Feels to Be Me," 1997
Sound City Studio
Van Nuys, California

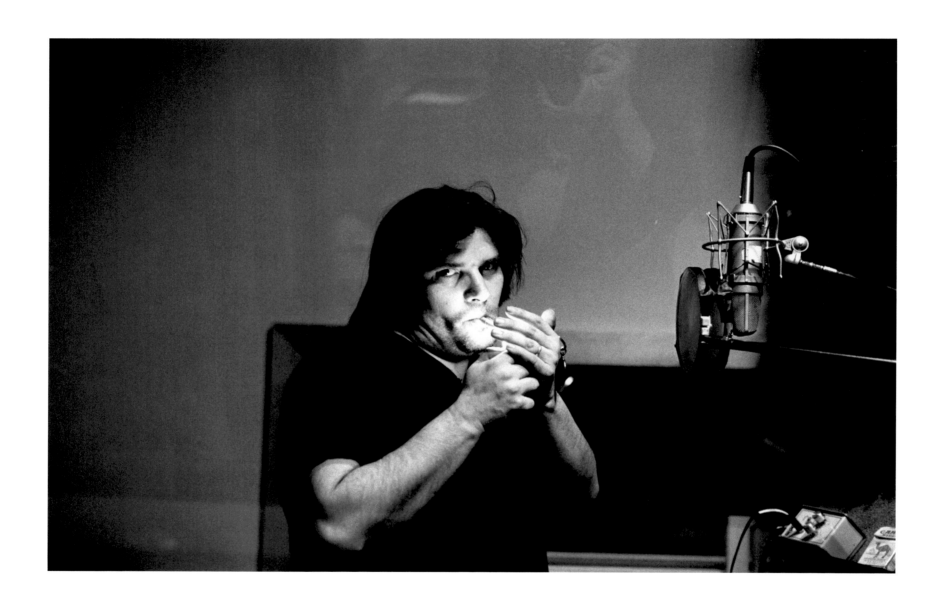

Steve Earle Talking Blues, 1995
Nashville, Tennessee

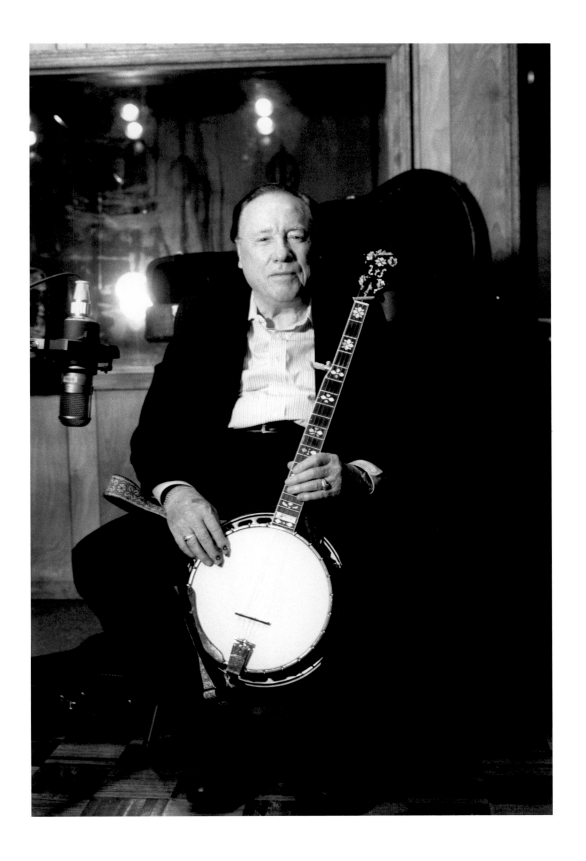

Earl Scruggs, 1998
Nashville, Tennessee

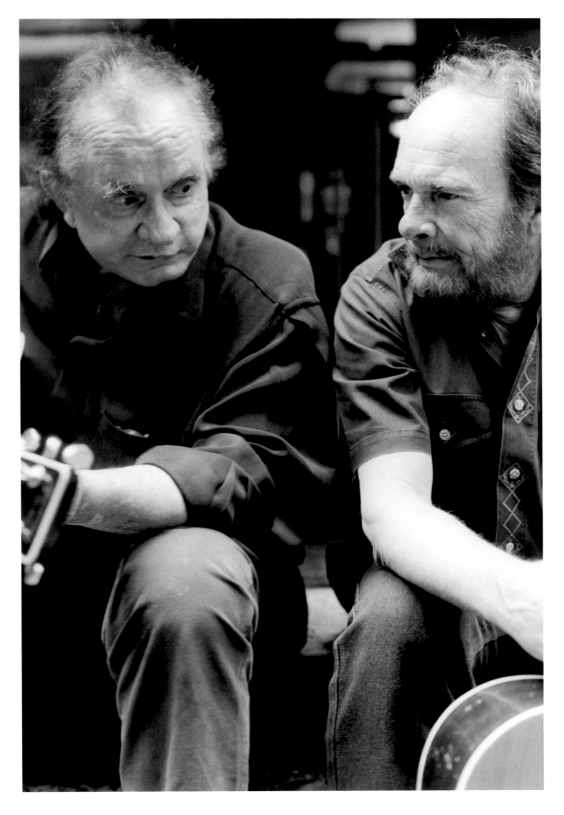

Last Meeting, Johnny Cash and Merle Haggard, 2002
Cash Cabin Recording Studio
Hendersonville, Tennessee

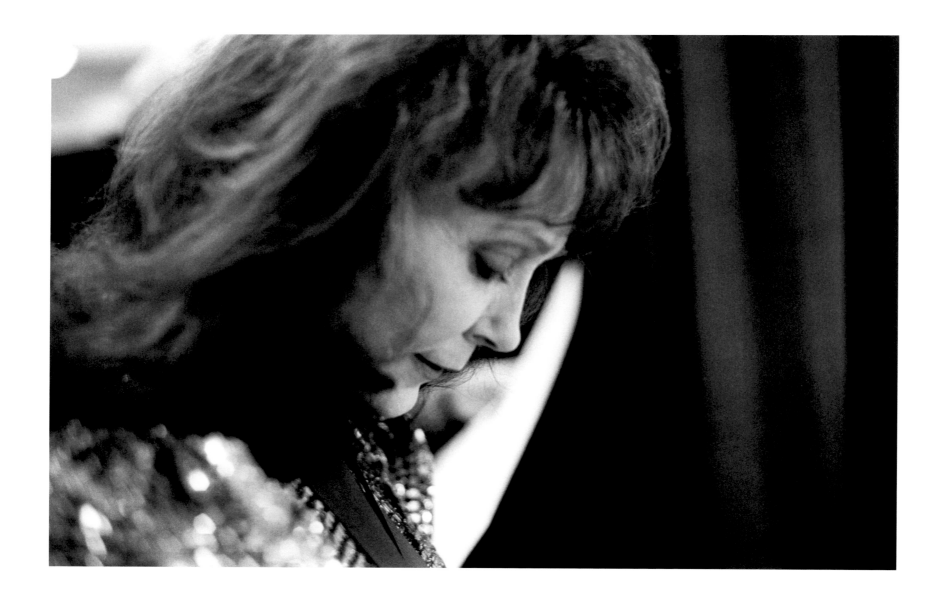

Loretta Lynn, Blue Kentucky Girl, 1994
Ryman Auditorium
Nashville, Tennessee

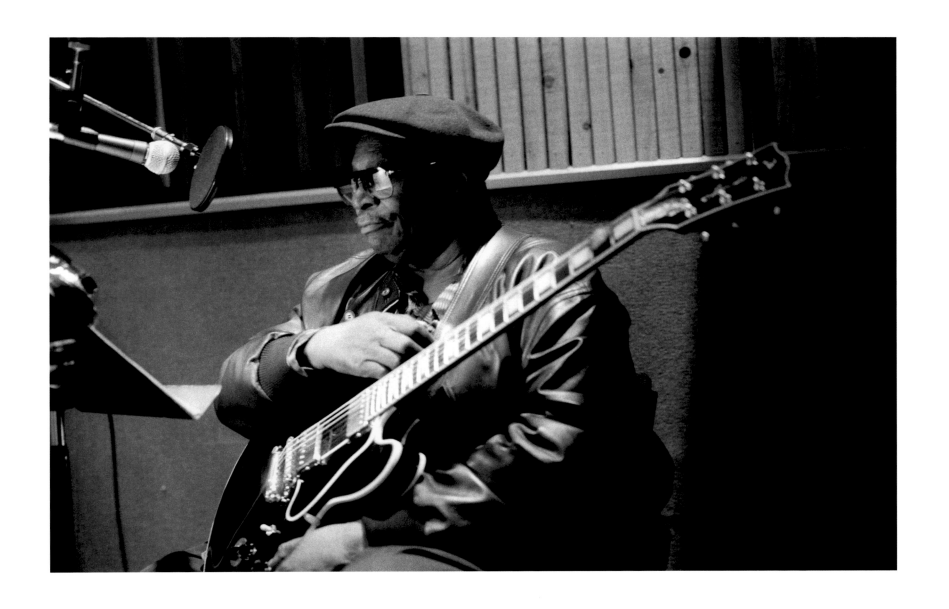

B.B. King, the King of the Blues, 1997
A&M Studios
Hollywood, California

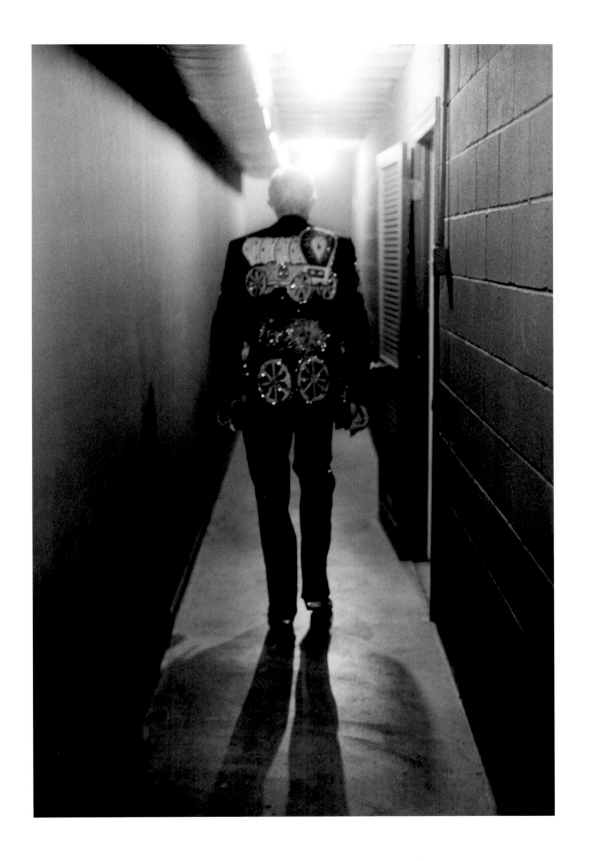

Porter Wagoner, the Wagonmaster, 1999
Nashville, Tennessee

BLUE LINE HOTSHOTS

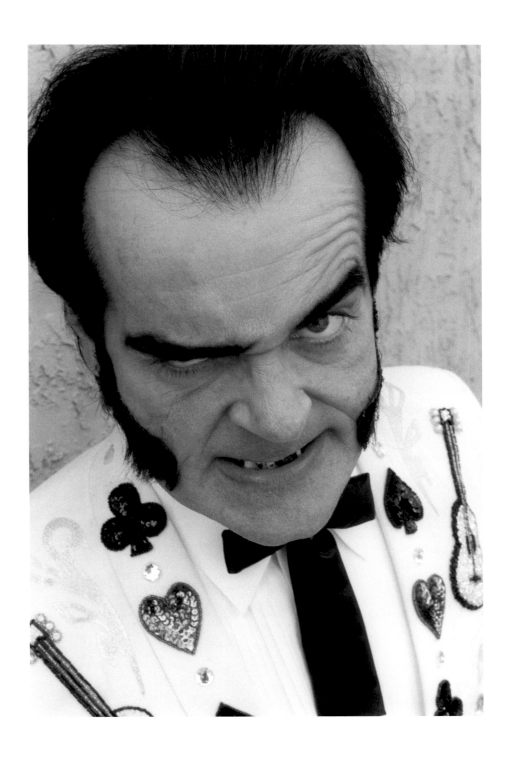

Unknown Hinson, the Country Music Dracula, 2001
Nashville, Tennessee

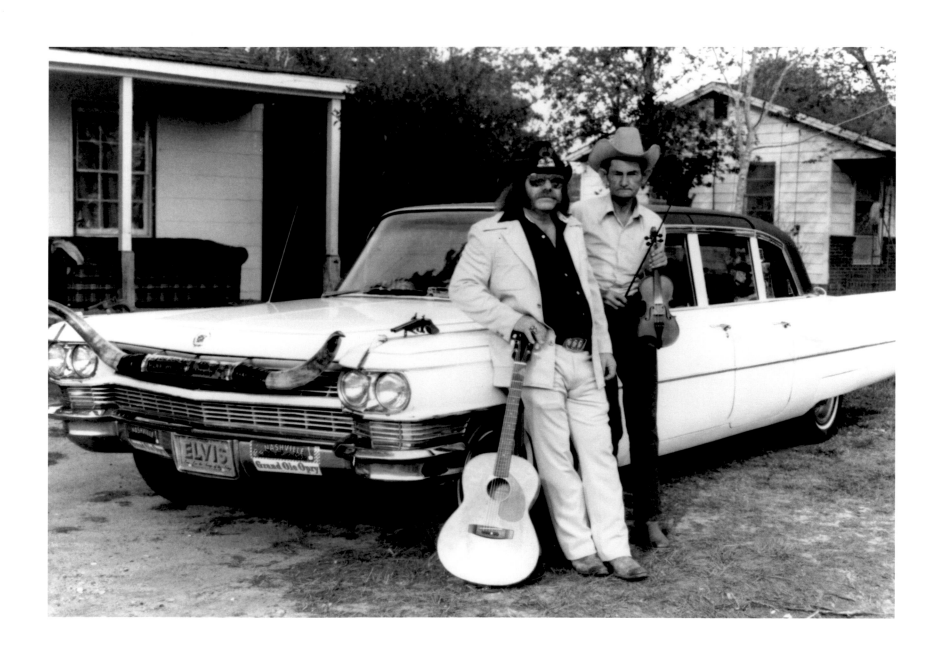

The Carolina Boys, 1979
Gaffney, South Carolina

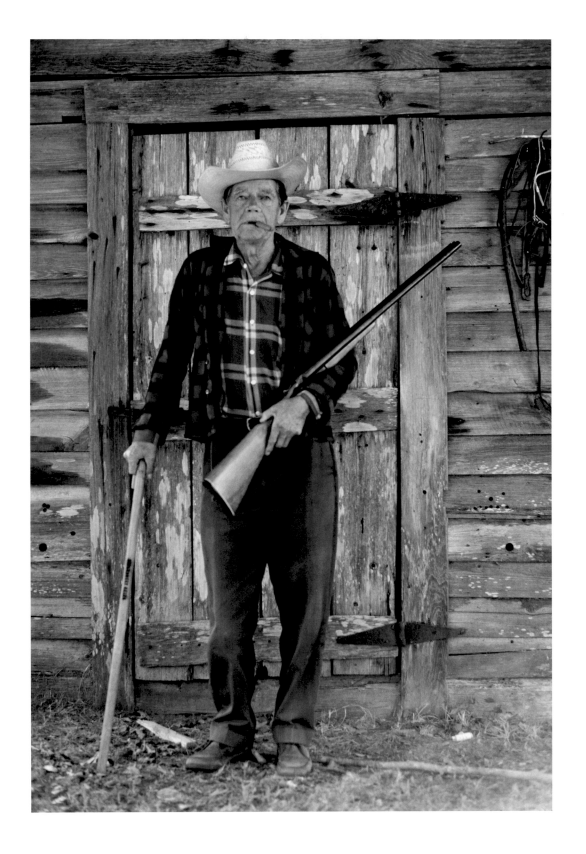

My Grandpa, Levi Lincoln Stuart, 1978
Arlington, Mississippi

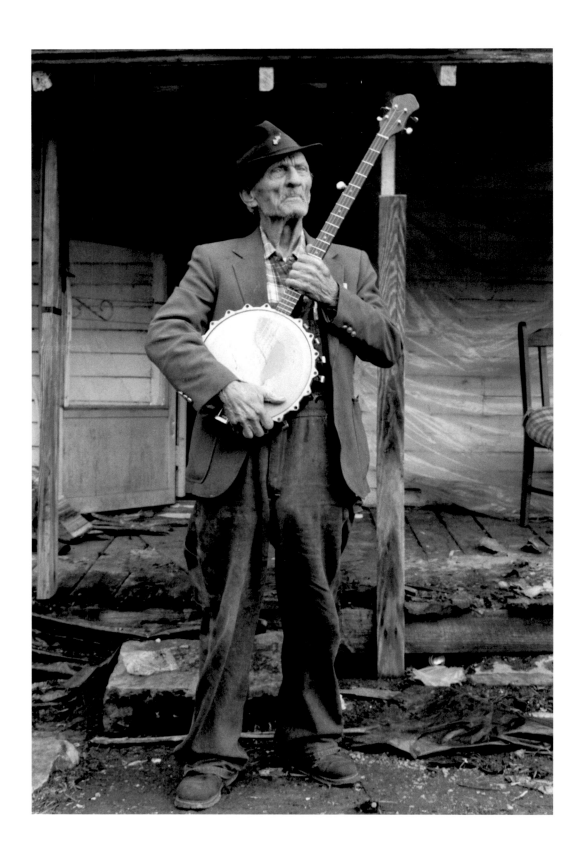

Sir Cordell Kemp, 2000
Defeated Creek, Tennessee

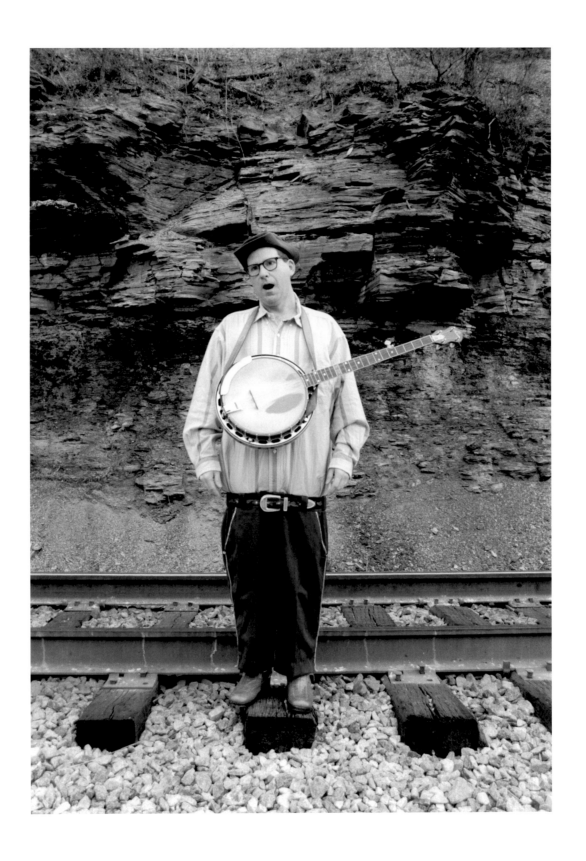

Leroy Troy as Stringbean, 2004
Goodlettsville, Tennessee

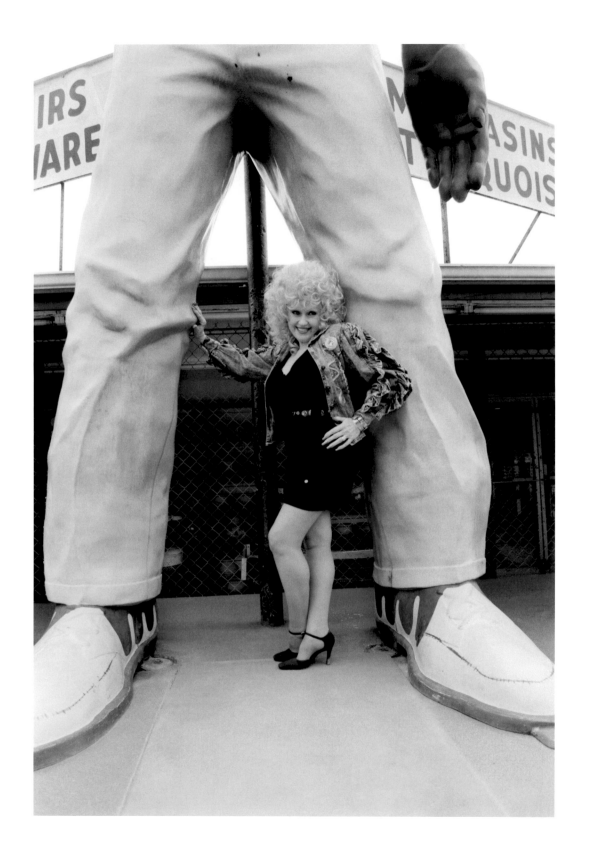

Miss Sharlene as Dolly Parton, 2005
Cherokee, North Carolina

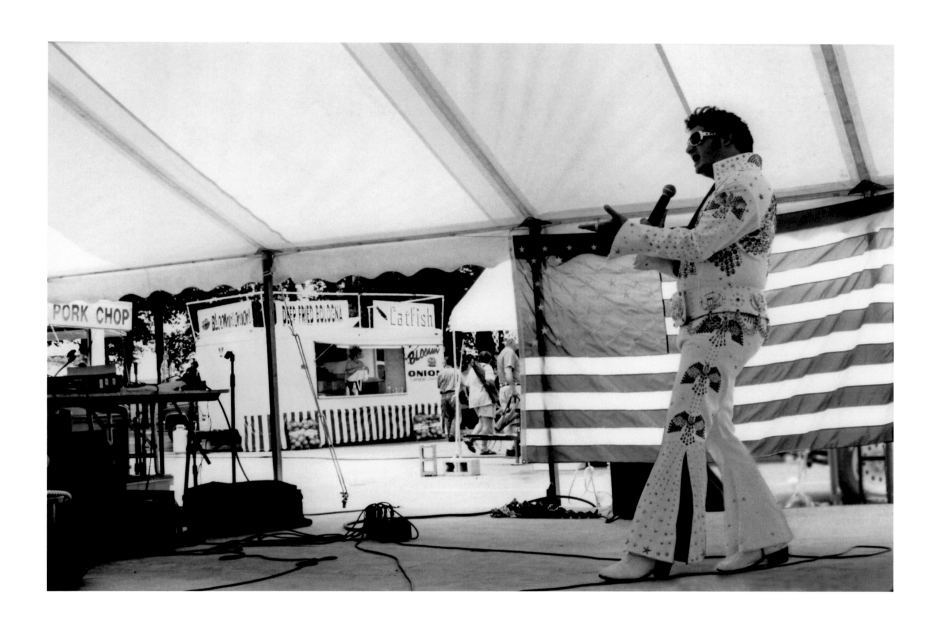

Elvis, 2001
Tupelo, Mississippi

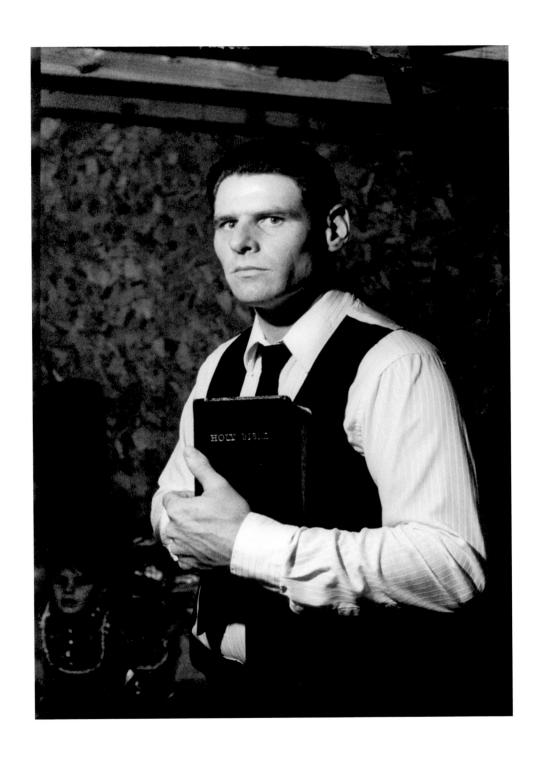

Brother Phillip Holloway, Happy Hollow Holiness Church, 1989
Turkey Creek, Louisiana

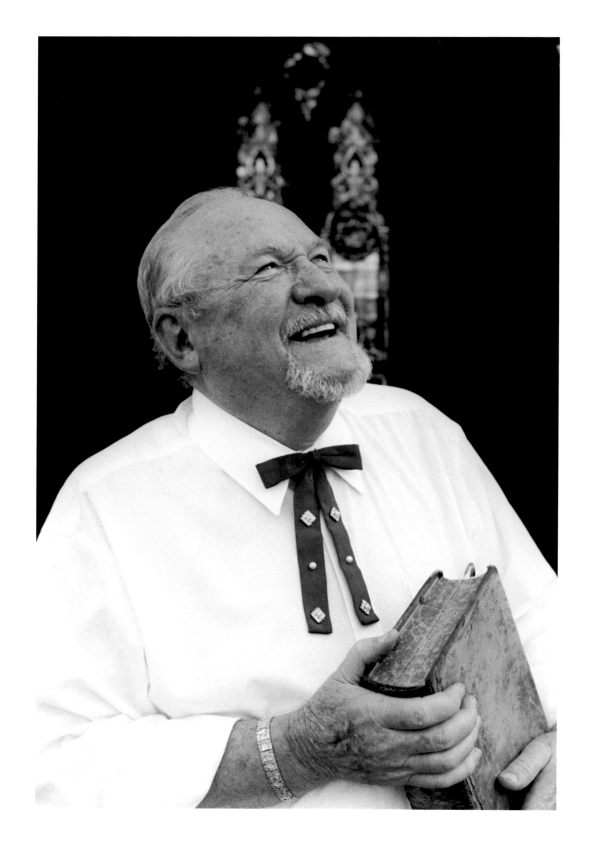

Reverend Leamon Flatt, 2004
Murfreesboro, Tennessee

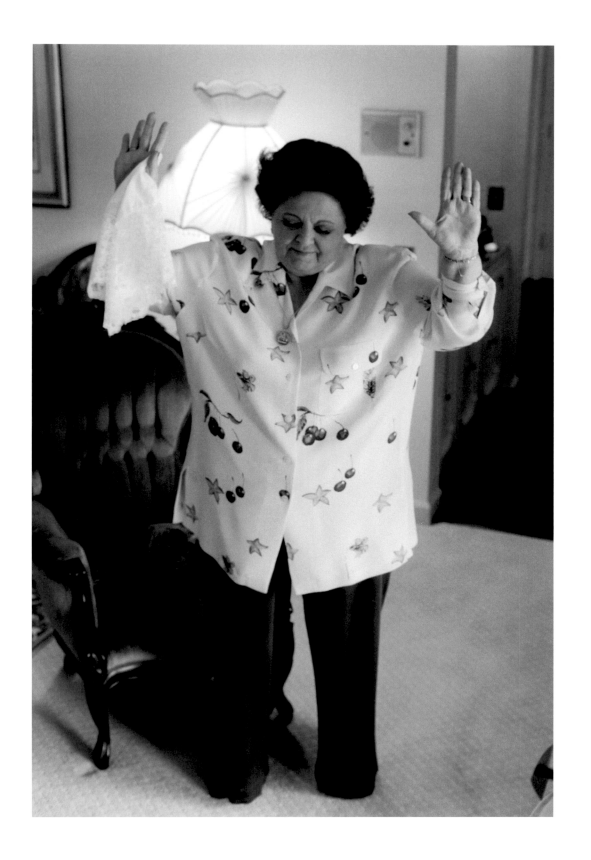

Sister Vestal Goodman, 1999
Brentwood, Tennessee

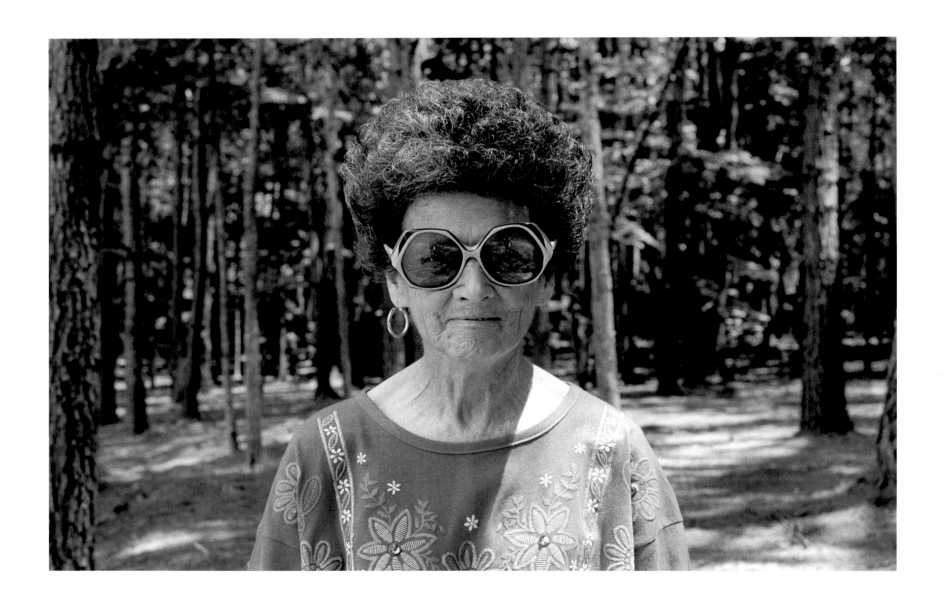

Aunt Waldine, 1995
Burnside, Mississippi

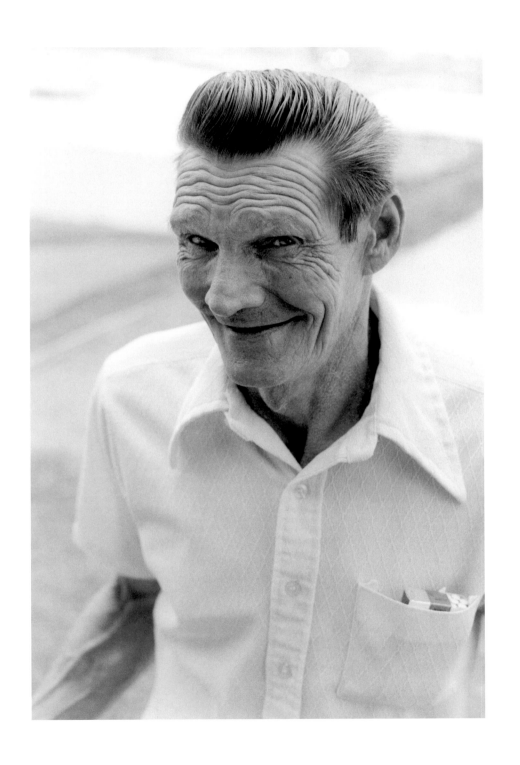

Rockabilly Man, 2001
Reinholds, Pennsylvania

The Knoxville Girls at Dollywood, 1995
Pigeon Forge, Tennessee

Best Friends, 2005
Muncie, Indiana

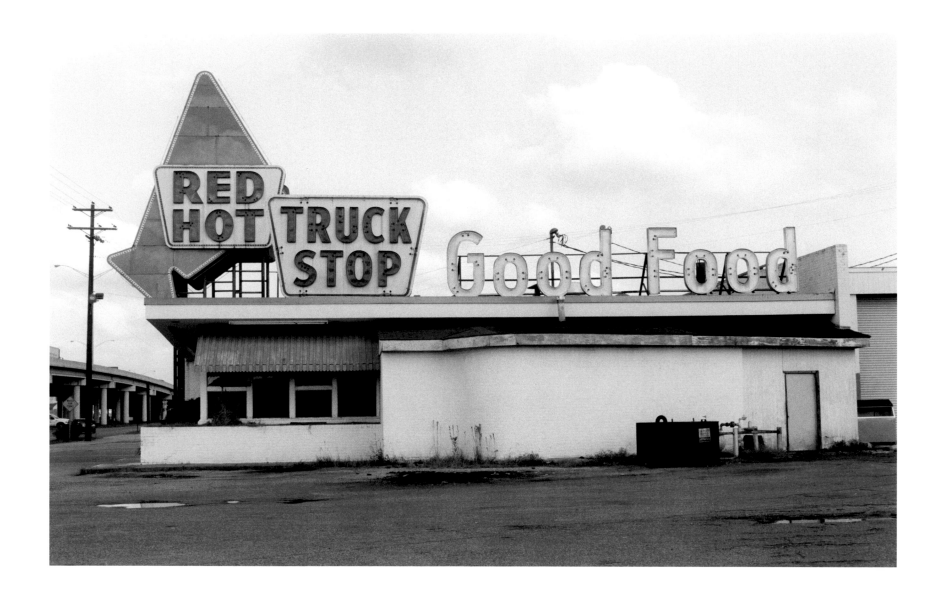

The Red Hot Truck Stop, 1999
Meridian, Mississippi

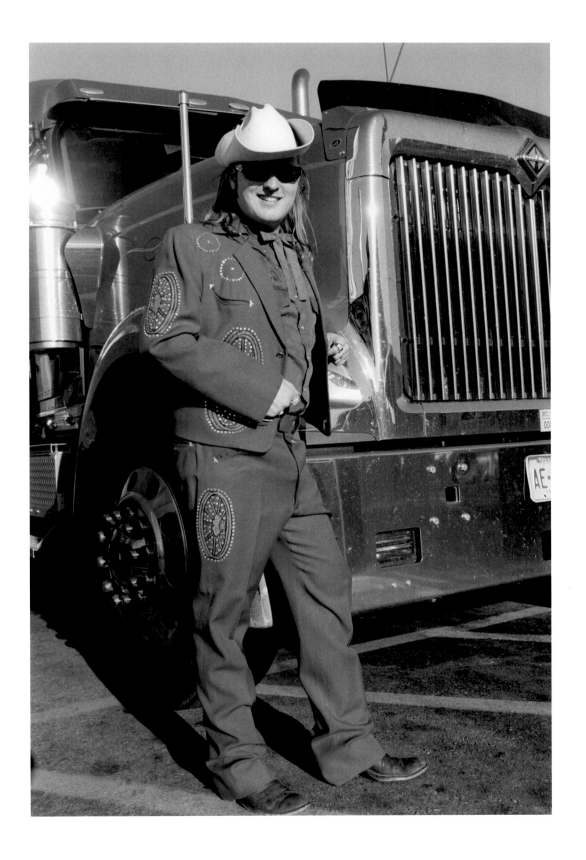

Truck Stop King, Matt Reasor, 2006
Ames, Iowa

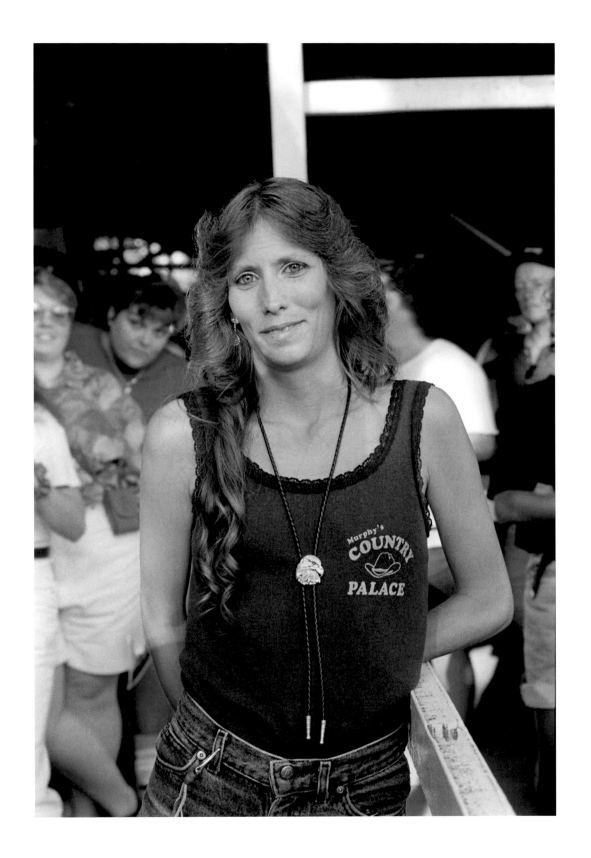

Country Music Fan, 1996
Westgrove, Pennsylvania

Show Girls, Highway 61, 2004
Mississippi/Tennessee State Line

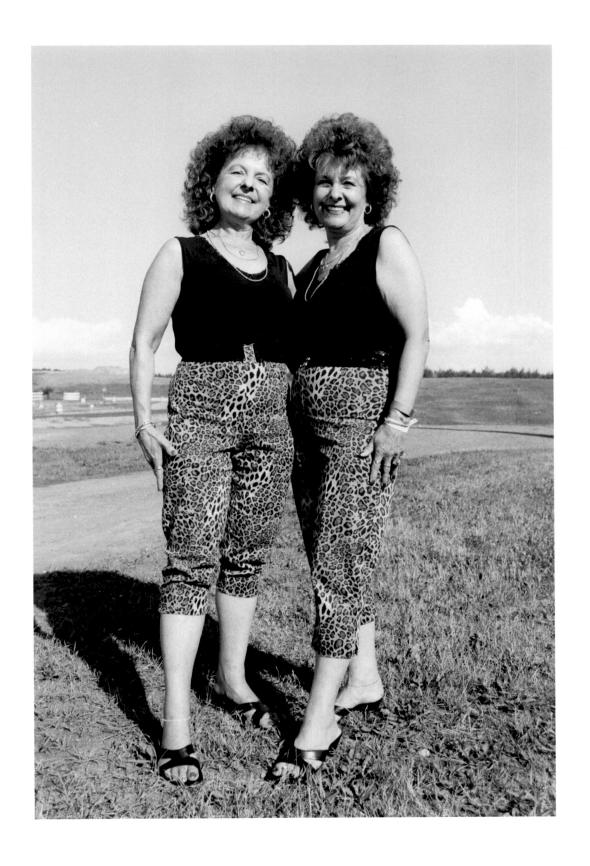

The Minnesota Twins, 2006
Hinckley, Minnesota

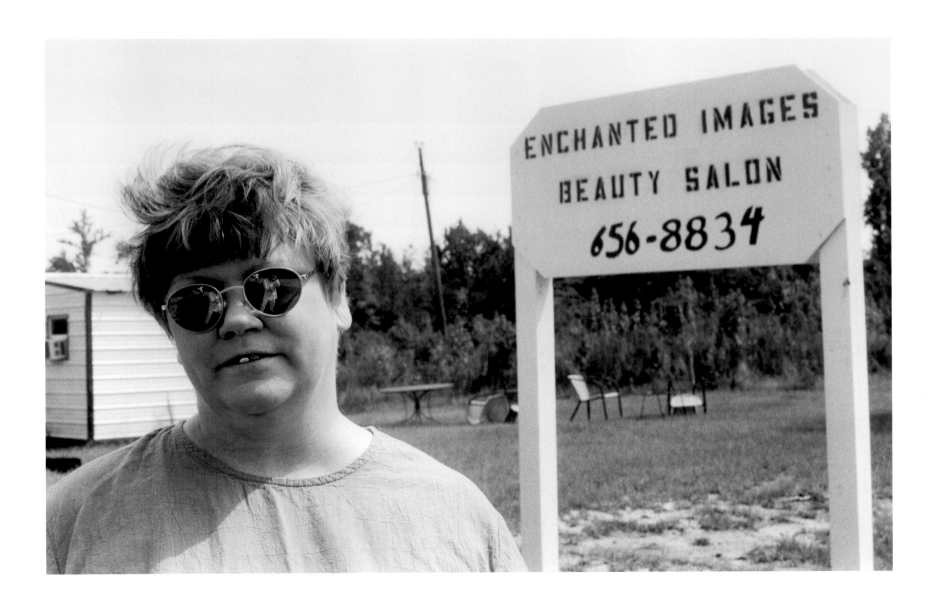

Proprietress of the Enchanted Images Beauty Salon, 2000
Arlington, Mississippi

BADLANDS

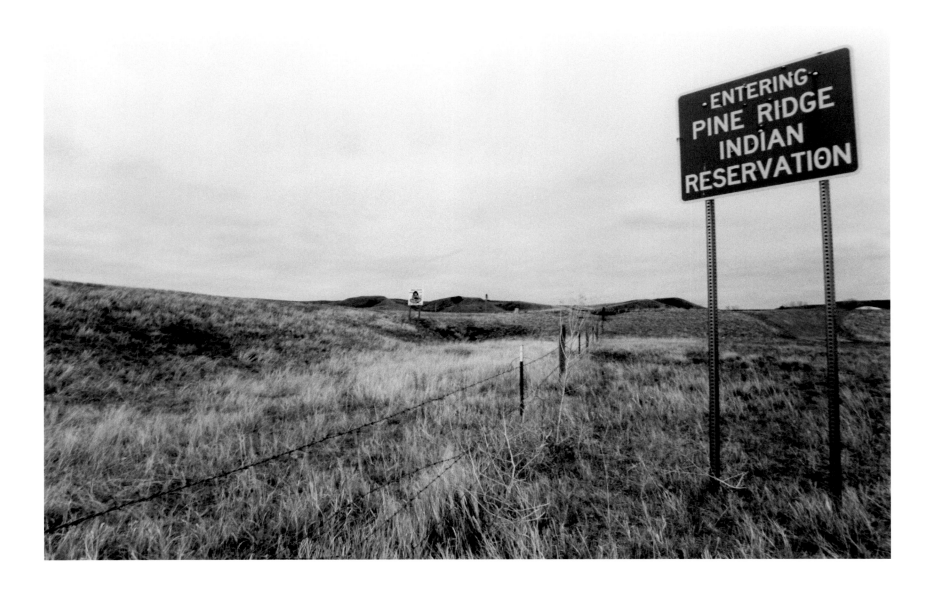

Entering Pine Ridge Indian Reservation, 2005
Red Shirt Table, South Dakota

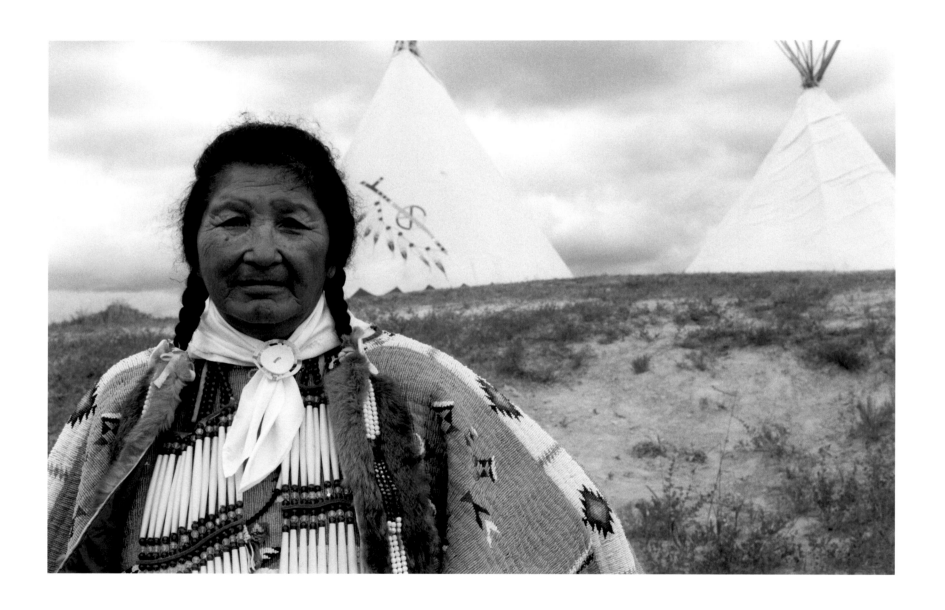

Millie Black Bear, 2000
Oglala, South Dakota

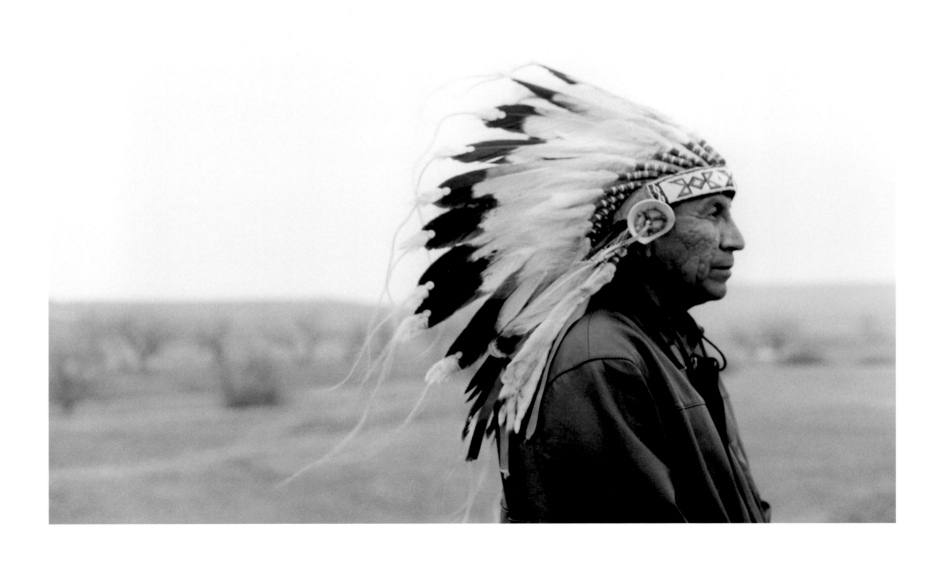

Orville Looking Horse, 2004
Green Grass, South Dakota

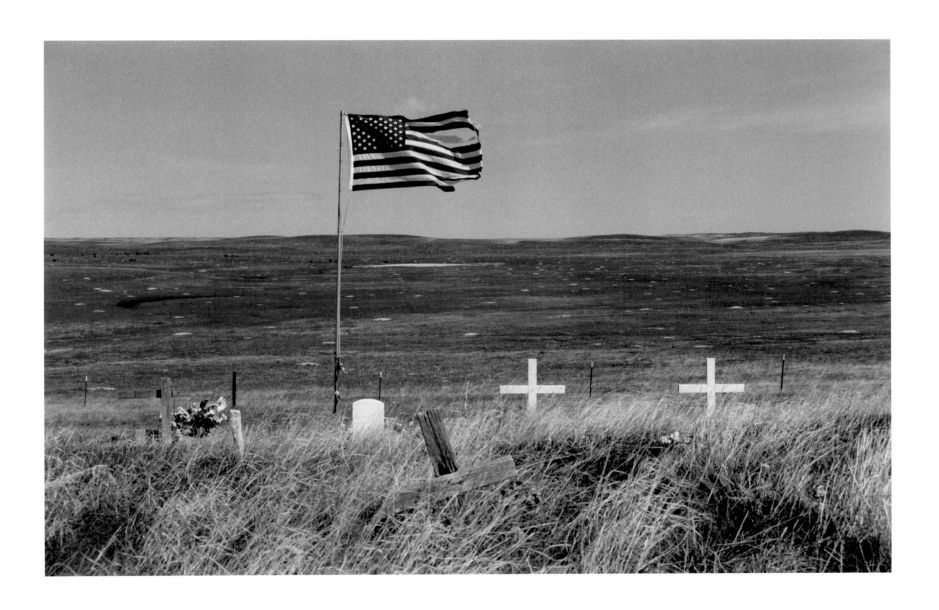

Winds of Time, 2006
Pine Ridge, South Dakota

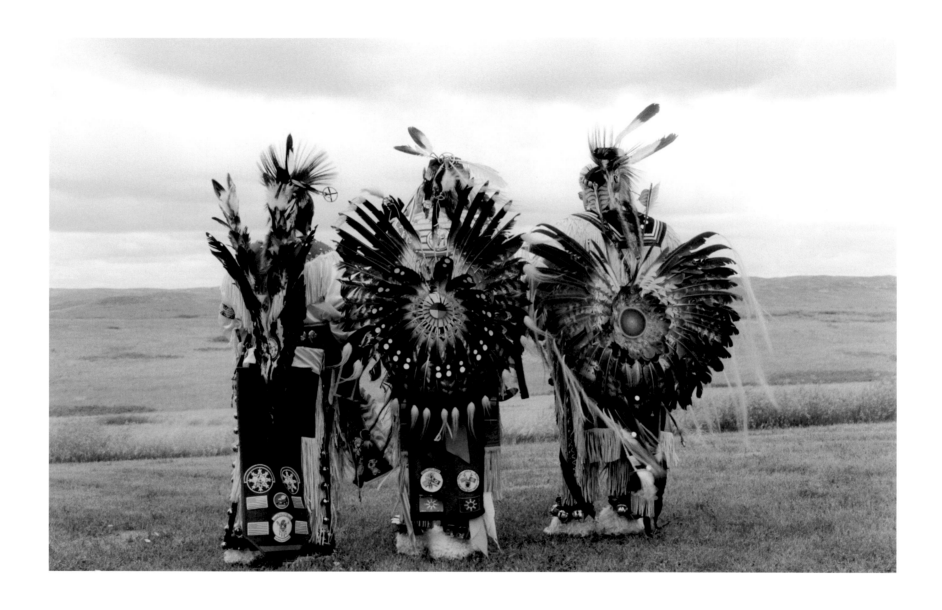

Eagle Dancers, 2000
Oglala, South Dakota

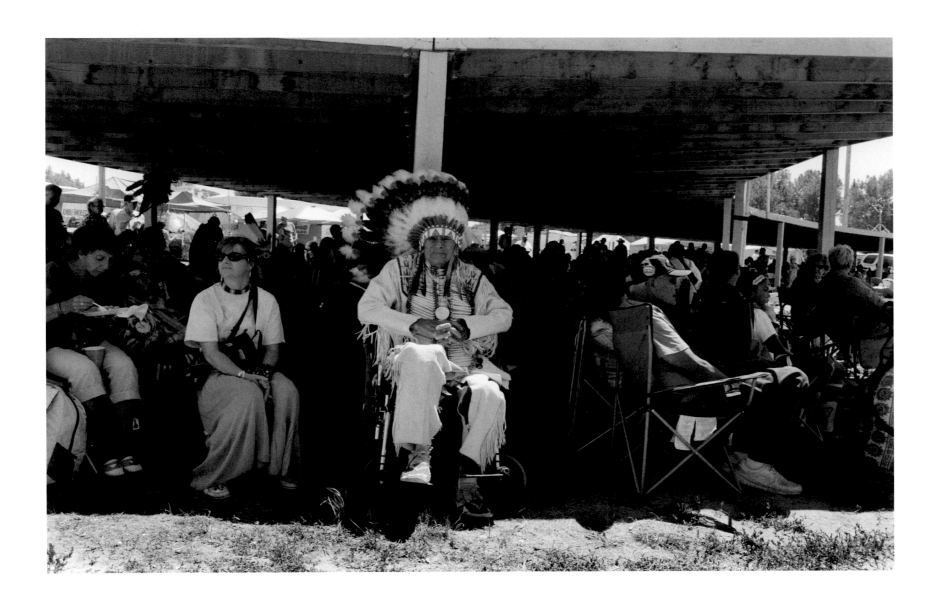

Chief Oliver Red Cloud, 2012
Pine Ridge, South Dakota

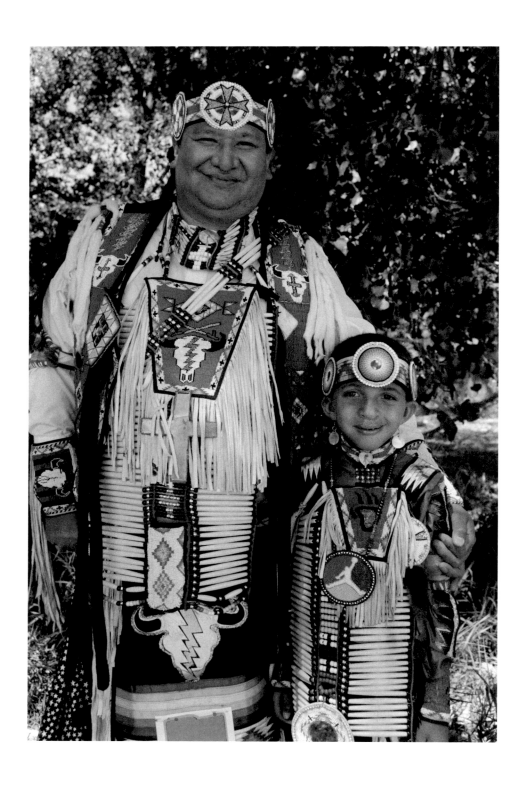

Lonnie Richards and Son, 2012
Pine Ridge, South Dakota

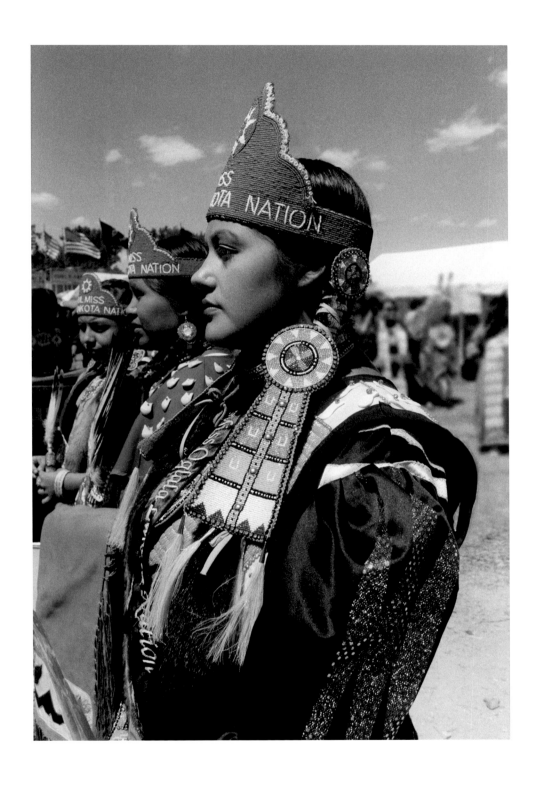

Miss Oglala, Lakota Nation, 2012
Pine Ridge, South Dakota

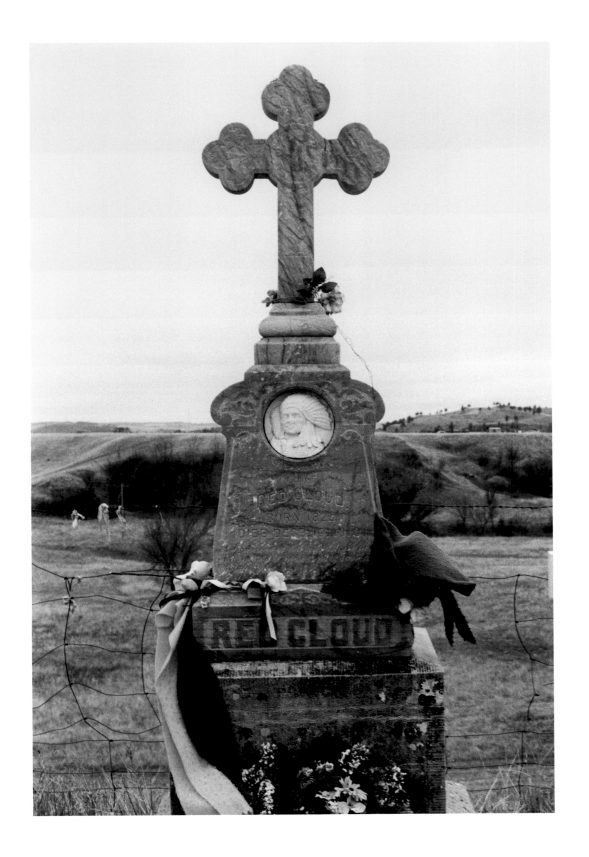

Red Cloud Tomb, 2004
Pine Ridge, South Dakota

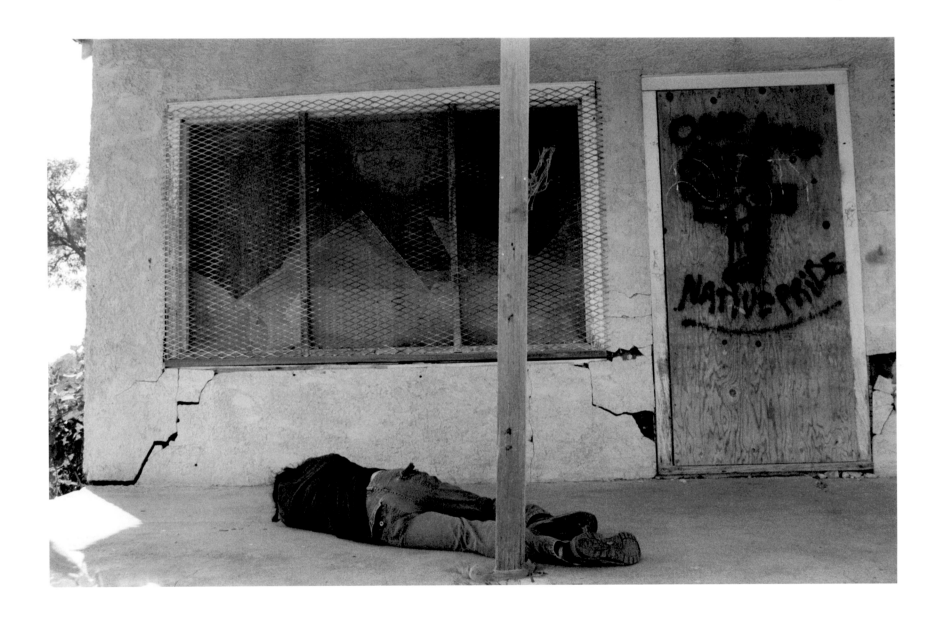

One Love, Native Pride, 2012
Pine Ridge, South Dakota

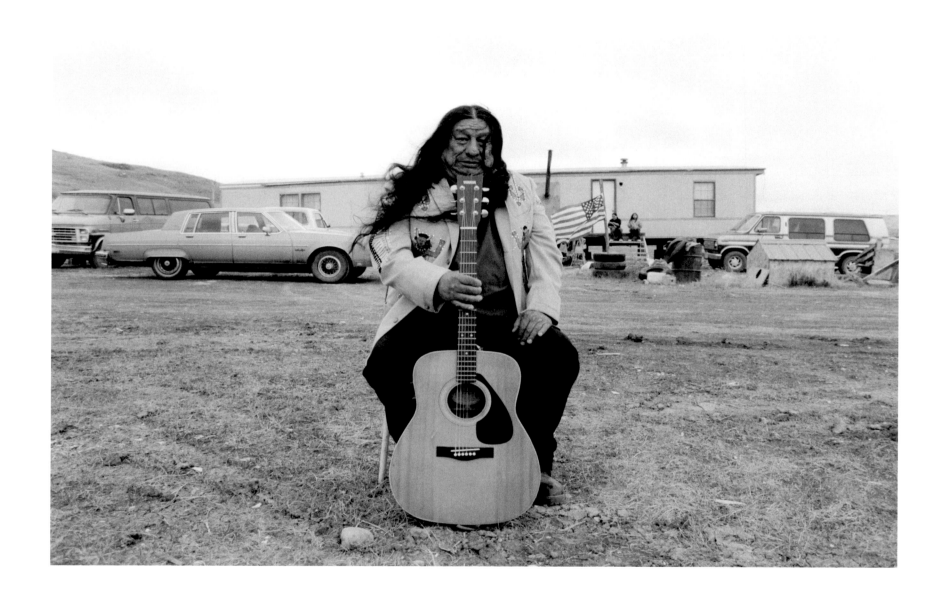

Marvin Helper at Home, 2005
Red Shirt Table, South Dakota

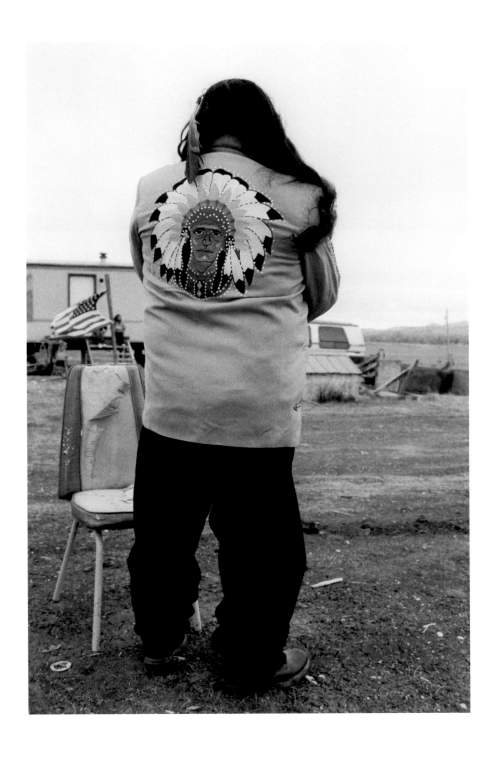

Marvin Helper at Home, 2005
Red Shirt Table, South Dakota

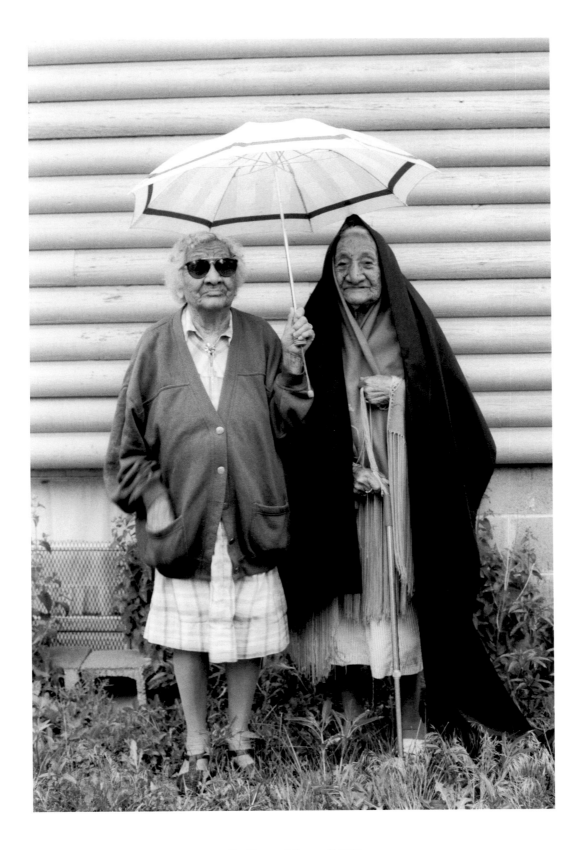

Sadie and Zona, 2000
Pine Ridge, South Dakota

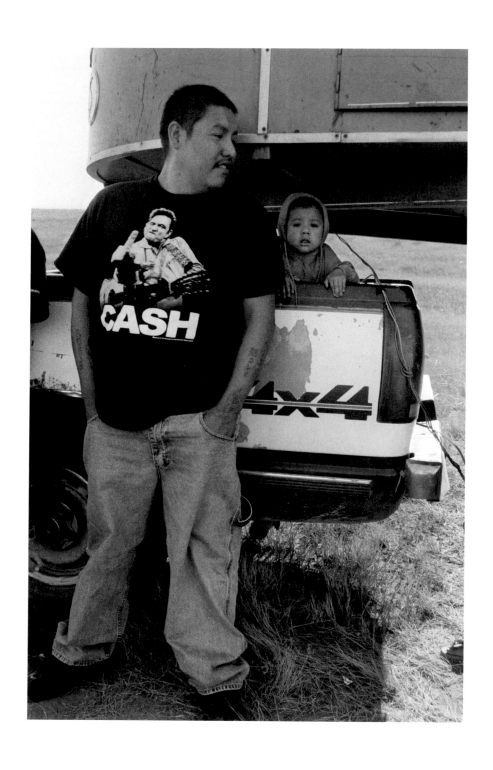

Cash on Pine Ridge, Pine Ridge Pow Wow, 2012
Pine Ridge, South Dakota

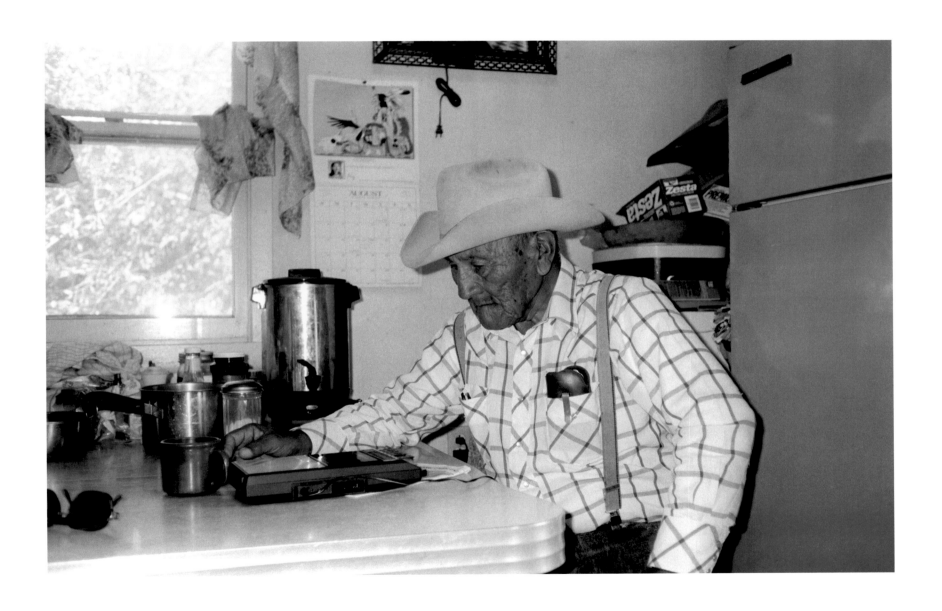

A Song for Johnny Cash, Mr. William Horn Cloud, 1991
Pine Ridge, South Dakota

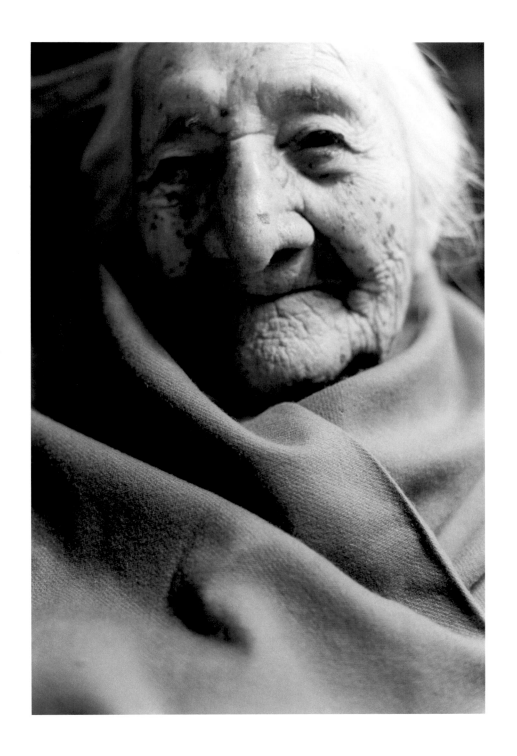

Zona Fills the Pipe, 2000
Pine Ridge, South Dakota

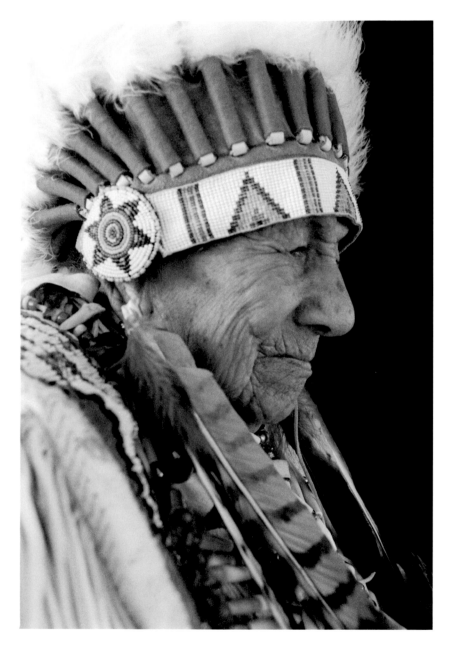

Chief Oliver Red Cloud, 2012
Pine Ridge, South Dakota

Lakota Child, 2012
Rapid City, South Dakota

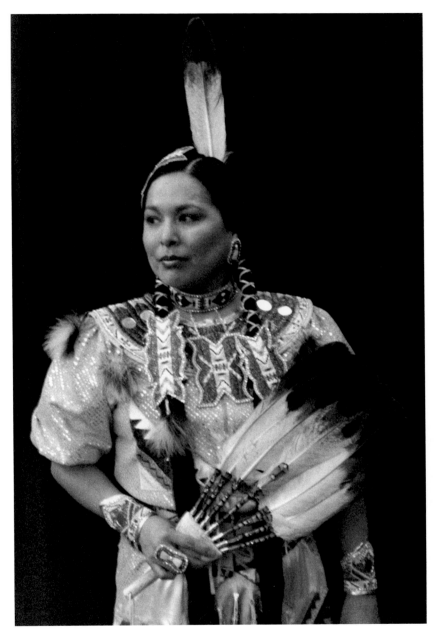

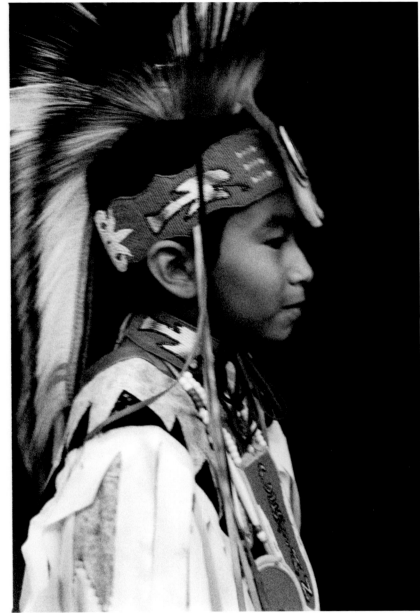

Lakota Queen, 2012
Rapid City, South Dakota

Lakota Boy, 2012
Rapid City, South Dakota

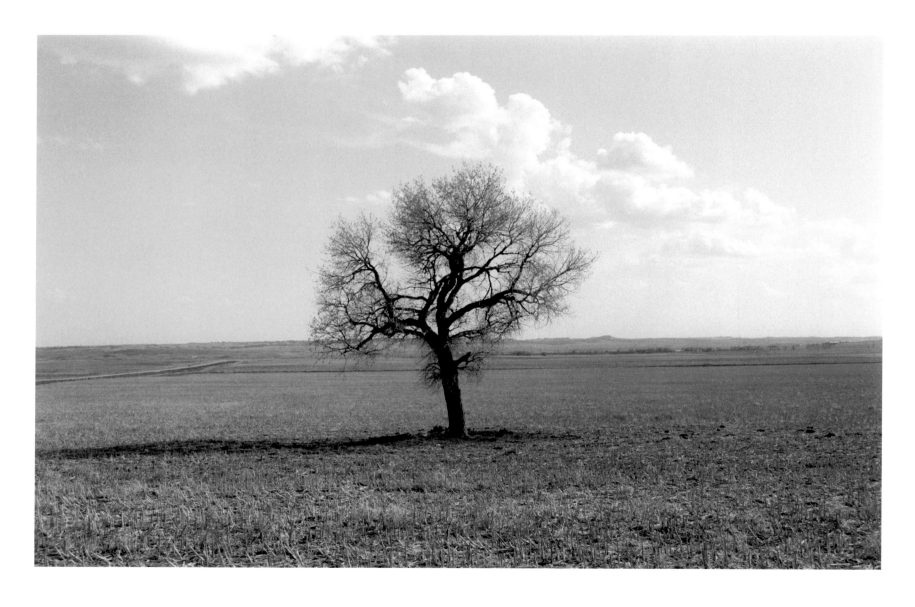

Tree in the Badlands, 2005
Red Shirt Table, South Dakota

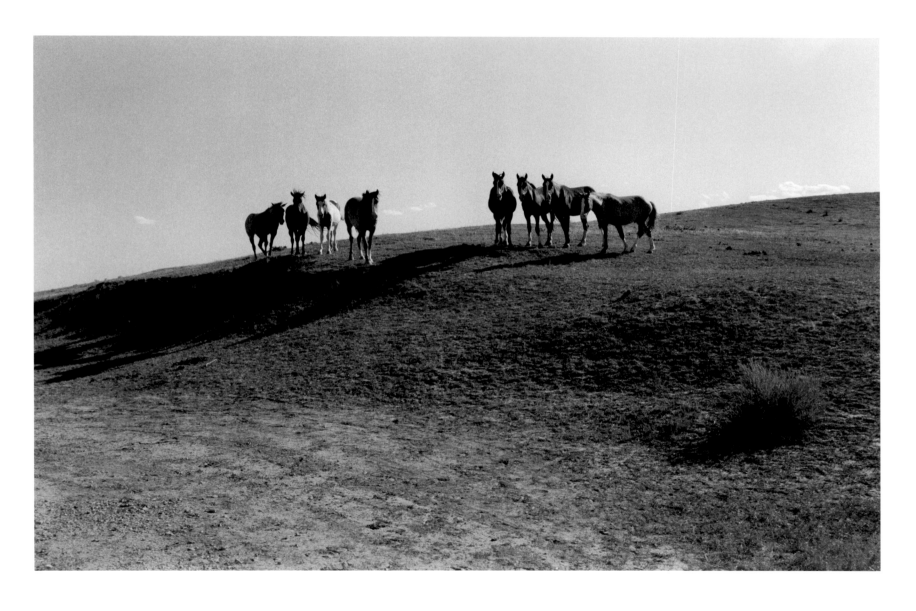

Horses at Wounded Knee, 2012
Pine Ridge, South Dakota

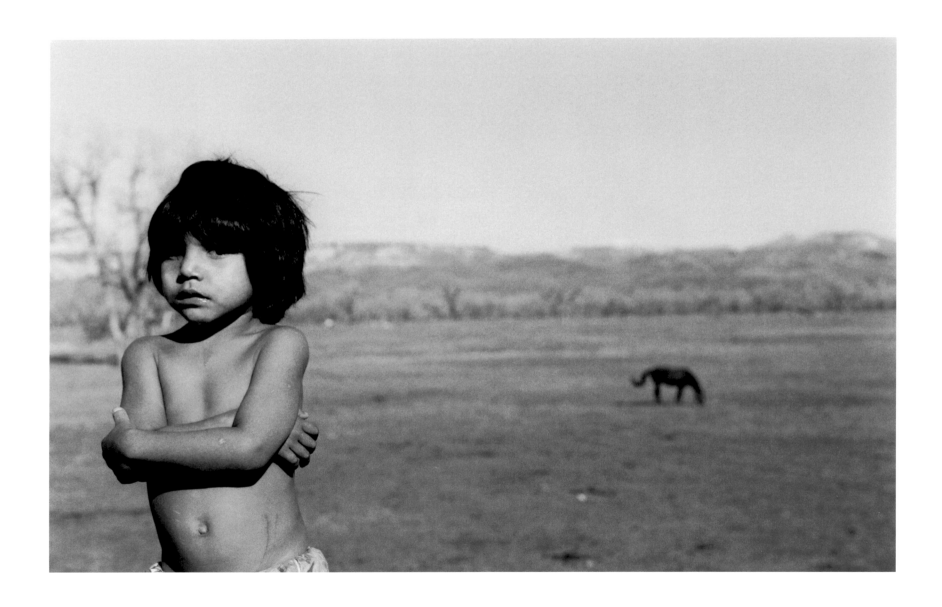

Noah, 2004
Red Shirt Table, South Dakota

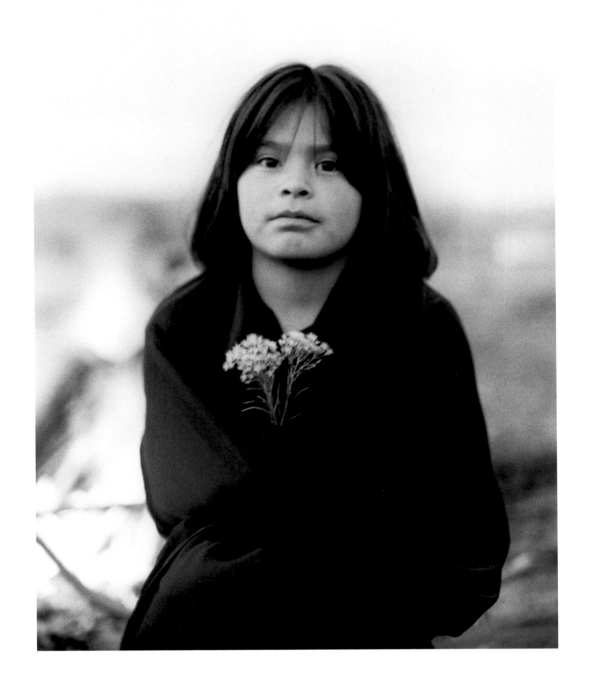

Brittany Fast Wolf, 2004
Red Shirt Table, South Dakota

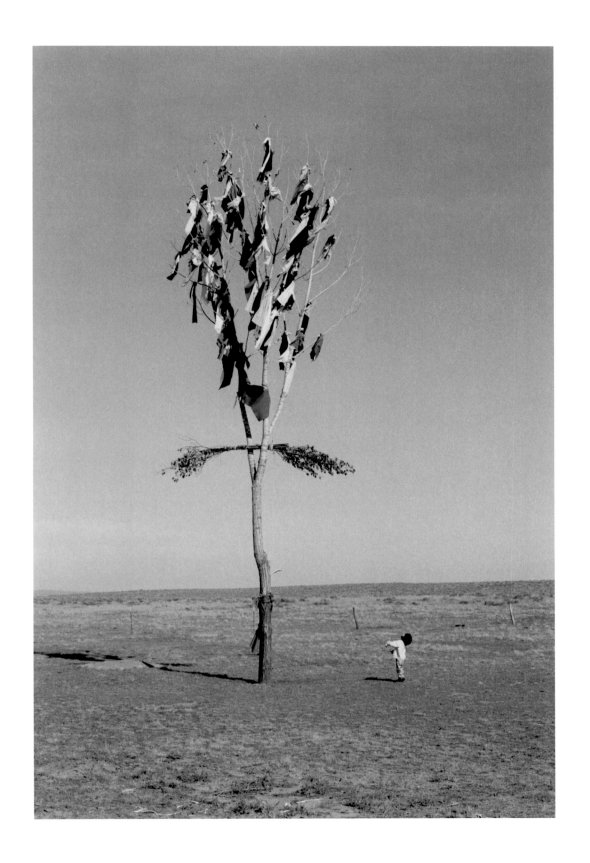

Noah by the Sundance Tree, 2004
Red Shirt Table, South Dakota